DATE DUE

			PRINTED IN U.S.A.

Timken
Art Gallery

*European and American
Works of Art in the
Putnam Foundation
Collection*

Foreword by Nancy Ames Petersen
Catalogue Entries by Agnes Mongan
Elizabeth Mongan
Cecil Gould
Michael Quick

Timken
Art Gallery

*European and American
Works of Art in the
Putnam Foundation
Collection* Visited 3/18/93

Putnam Foundation San Diego, California 1983

A revised and enlarged edition of *European Paintings in the Timken Art Gallery*

Copyright © 1983 by the Putnam Foundation

No part of this book may be reproduced without the written consent of the Putnam Foundation, Timken Art Gallery, Balboa Park, San Diego, California 92101.

Library of Congress Cataloging in Publication Data
Timken Art Gallery.
 Timken Art Gallery.
 Bibliography: p. 115
 Includes index.
1. Painting—California—San Diego—
 Catalogs.
2. Putnam Foundation—Art collections—
 Catalogs.
3. Timken Art Gallery—Catalogs.
 I. Putnam Foundation. I. Title.
N737.5.A66 1983 759.94′074′019498
83-60021
ISBN 0-9610866-0-2
ISBN 0-9610866-1-0

Cover:
Rembrandt
Saint Bartholomew (detail)
catalogue number 26

Design by Lilli Cristin, Glendale, California
Photography by Lorenzo Gunn, San Diego, California
Text set in Bembo by R S Typographics, North Hollywood, California
Printed by George Rice and Sons, Los Angeles, California

Contents

This catalogue of the collection is respectfully dedicated to Allen J. Sutherland, President of the Putnam Foundation

Foreword

The birth of San Diego's cultural community was largely the result of the combined efforts and generosity of two families: the prominent Timken family from Canton, Ohio, and two of the Putnam sisters who arrived in San Diego with their family in the early 1900s.

In 1925 Mrs. Appleton Bridges, a member of the Timken family, and her husband put forth the necessary funds for the construction of the Fine Arts Gallery, a strikingly handsome, two-storied building which was designed to fit the pseudo-Spanish architecture established in Balboa Park during the 1914 Exposition. Upon its completion the local Fine Arts Society assumed the operation of that gallery. However, it was Mr. and Mrs. Bridges who were its principal supporters, paying the director's salary and that of the one guard employed by the Society. That was all the security we needed in those days!

Soon after the death of Mrs. Bridges in 1940, the Putnam sisters, Anne (1867–1962) and Amy (1874–1958), well educated in the arts, stepped forward with generous financial support. Anne and Amy, who never married, lived close to Balboa Park in the stately family mansion at Fourth and Walnut Streets. During the 1940s they began to purchase paintings of distinction, anonymously donating them to the Fine Arts Gallery. These gifts, for the most part, represented the Italian and Spanish schools. As a result of their generosity, the San Diego Museum of Art, formerly the Fine Arts Gallery, today maintains a distinguished collection of Spanish paintings.

In 1950 the sisters decided to establish a long-range program for the continued use of their wealth and sought the advice and counsel of their friend and attorney, Walter Ames. With his guidance they established the Putnam Foundation. In accordance with their wishes, the new foundation continued to purchase paintings of high quality. These works of art, however, were not destined to be exhibited at the Fine Arts Gallery, but were to travel on loan to various institutions throughout the country. For over a decade the National Gallery of Art in Washington, D.C., New York's Metropolitan Museum of Art, Harvard University's Fogg Art Museum, and The Art Institute of Chicago exhibited Putnam acquisitions.

Although no members of the Timken family resided in San Diego after Mrs. Bridge's death, the Timkens retained an active interest in the community. Walter Ames consulted with his client, Henry H. Timken, Jr., and the Timken Foundation offered to pay a substantial part of the cost of a new gallery for San Diego.

Its purpose was to allow the return to San Diego of those Putnam paintings on loan to museums in the East.

The services of architect Frank Hope were retained. He toured the nation's museums with Ames, visiting and conferring with such luminaries as James Rorimer, Director of the Metropolitan Museum; John Walker, Director of the National Gallery of Art; and Ernest Fiedler, Administrator of the National Gallery. The end result is an elegant building where the architecture does not obscure the art.

In October 1965 the doors of the new gallery were opened to the public. The institution was named the Timken Art Gallery because of the generous contributions to the arts that the Timken family had made to the community. The formal, contemporary building of bronze, glass, and travertine marble harmonizes surprisingly well with the baroque facade of the adjacent San Diego Museum of Art. At the Gallery's opening John Walker referred to the Timken as a "jewel box for the arts," a name still used today.

When the Gallery opened, the Fine Arts Society graciously loaned twenty of their finest paintings which had been purchased for them by the Putnam sisters. These paintings hung with twenty paintings owned by the Putnam Foundation. One gallery—lined with rich, green cut-velvet cloth woven in Italy expressly for the Timken—houses a rare collection of Russian icons. This collection was started by Amy Putnam who had taken courses in Russian at Stanford University. Over a period of forty years she collected many Russian works of art and books and over three hundred icons. For the opening of the Timken Gallery approximately sixty of the most important icons were selected for exhibition in the Amy Putnam Icon Room. (The collection will not be reviewed in this catalogue, but it is hoped that in a few years a separate catalogue will be prepared to cover this collection.)

In the years following the opening of the Timken, day-to-day operations, supervision of the staff, and selection of acquisitions were under the direction of Walter Ames, President of the Putnam Foundation, who insisted on excellence in every phase of the Gallery's operation. Though Ames was educated at Stanford University as a lawyer, he had a remarkable eye for fine art, and from 1965 until his retirement in 1978 he enjoyed contacts with the foremost dealers in the art world. He counted as his friends and advisors such men as Robert C. Vose of the Vose Galleries, Evelyn Joll of Thomas Agnew and Sons, London, David Carritt

with Artemis, London, and Louis Goldberg of Wildenstein's, all of whom encouraged acquisitions of quality. Another such advisor was Alfred Frankfurter, editor of *Art News*. In addition to calling upon leading art historians for advice, Ames hired distinguished scholars for specified periods. Agnes Mongan of Harvard University and the Fogg Museum; her sister, Elizabeth Mongan who served at the National Gallery, Washington, D.C.; Dr. A. B. de Vries, past Director of the Mauritshaus in Amsterdam; and George L. Stout, past Director of the Isabella Stewart Gardner Museum in Boston, all spent many months in San Diego offering recommendations and guidance. The present board of directors and the staff have not departed from this philosophy and continue to rely on leading authorities.

The collection encompasses examples of major European Old Masters of the French, Dutch, Flemish, and Italian schools dating from the early Renaissance. The Foundation owns one Spanish painting by Murillo and a small but choice selection of American paintings. Presently the American collection includes works from the late-eighteenth through nineteenth centuries. Four French sixteenth-century Gobelins tapestries line the walls of the main rotunda, and a late bronze cast of Giovanni da Bologna's *Mercury* is featured in the center of this room.

In 1980 the board of directors authorized a revised edition of the catalogue. Cecil Gould, past Keeper of the Collection at the National Gallery, London, agreed to author entries for the acquisitions to the European collection, the suite of Gobelins tapestries, and a small, delicate watercolor by the French artist, Gustave Moreau. Entries for the American collection are written by Michael Quick, Curator of American Art at the Los Angeles County Museum of Art. The Mongan entries on the Putnam paintings first published in 1969 have been preserved. However, additional information uncovered during recent investigation and research has been included. (The four remaining paintings on loan from the San Diego Museum of Art have not been included.)

This catalogue is intended as a handbook for those who wish to have a ready reference book available to assist them in viewing or studying the works of art in the Putnam collection. Infinite attention to historical accuracy and preparation of detailed bibliographies offer help to the many who may wish to enjoy further study. Reference material—provenance, literature, and exhibition histories—for all the works here catalogued is assembled at the end of this volume.

Both Cecil Gould and Michael Quick have been ably assisted in their research by Elizabeth Stevenson, a member of the Timken staff.

By virtue of his special talent, the color transparencies prepared by Lorenzo Gunn of San Diego take this edition out of the realm of the ordinary source book.

We would also like to express our appreciation to the many people who have given us their invaluable help and advice. To name a few, we thank Edward H. H. Archibald, Miklos Boskovits, David Brierley, William Chandler, Everett Fahy, David Faulkner, Professor I. G. van Gelder, Paulette Hennum, Nancy Moure, Professor Marie-Félicie Perez, John Petersen, Richard Reilly, Shirley Sawade, Dr. Yehuda Shabatay, Allen Staley, Theodore E. Stebbins, and Dr. M. Kirby Talley. In addition we extend our thanks to the many others who have been so gracious in contributing special information through letters and verbal communication.

Generous support and wise counsel in this project have been offered by the board of directors and especially by the president of the Putnam Foundation, Allen J. Sutherland

Nancy Ames Petersen
Director

European
Works
of Art

Introduction

Since the publication of the first catalogue of the Putnam Foundation collection, *European Paintings in the Timken Art Gallery,* by Agnes and Elizabeth Mongan, in 1969, the composition of the Gallery has been changed in two ways—by subtraction and by addition. Eighteen of the paintings which had been given by the Misses Putnam to the Fine Arts Society of San Diego were on loan in 1969 to the Timken Art Gallery and were therefore included in the catalogue. In the intervening years they have been returned to the San Diego Museum of Art. Ten new works have been added by the board of directors of the Putnam Foundation to the holdings of the Timken Art Gallery. The present edition of the catalogue reprints the Mongans' entries for pictures which are still in the Gallery, with additional bibliography in some cases. The European pictures which have been added to the collection since then have been catalogued by me, with welcome assistance from Elizabeth Stevenson. Each entry is followed by the initials of the author.

The brightest highlights of the Gallery as it was in 1969—the paintings by Petrus Christus, Pieter Bruegel the Elder, Savoldo, Philippe de Champaigne, Rembrandt, Metsu, Fragonard, J.-L. David, and Corot—were all acquisitions made by the Putnam Foundation and remain an integral part of the Gallery. The new acquisitions would rank as adornments of any art museum in the world. Most of them date from either the seventeenth century—the paintings by Claude, de Witte, Claesz, and Cagnacci—or the eighteenth—Carlevarijs, Largillierre, and Vernet. In addition, there is a fine sixteenth-century portrait, a signed work of Bartolomeo Veneto, and a nineteenth-century watercolor by Gustave Moreau. Unlike most of the earlier paintings in the collection, these additions include none of religious subject. With the exception of the Moreau, they are all landscape or still life or portraits, and in them some fascinating comparisons may be traced between the work of artists of different nationalities and different centuries when depicting similar subjects.

Joseph Vernet, for instance, a Frenchman voluntarily domiciled in his earlier years in Rome, liked to think of himself as the eighteenth-century counterpart of Claude Lorrain, another Frenchman, and one who, in the preceding century, had spent even more of his life in voluntary exile in Rome. The Mediterranean light is beautiful enough in itself, one might think. But both Claude and Vernet tended to idealize its effects and softened the irregularities of the landscape. In the Timken Art Gallery we may study the two artists in juxtaposition.

When two paintings of still life are compared—those by Cagnacci and Claesz—there is little difference of period. Both date from around the middle years of the seventeenth century, and the difference of the nationality of the artists—Italian and Dutch—has produced less difference in effect than might be expected. Both artists have depicted honestly and without "improvements" very ordinary objects—a vase of flowers and a simple meal—on perfectly plain wooden tables. The Italian allows himself stronger contrasts of color and light, the Dutchman a greater harmony of muted shades.

A similar community of interest between a Dutch artist and an Italian may be traced in the topographical paintings. Emanuel de Witte of Amsterdam and Luca Carlevarijs of Venice are both likely to have taken slight architectural liberties—with the New Church at Amsterdam in the one case, and with the Piazzetta at Venice on the other. But despite this, they both, in all probability, give us a reliable general impression of the appearance of the buildings and of the people who were then to be seen in them. But whereas these people are a world apart from their modern counterparts, the buildings themselves—the Amsterdam church and the Venice square—survive almost unchanged.

When we come to a comparison of the portraits we must take a much bigger jump in time. Yet the theme of human vanity is seen to be much the same in eighteenth-century France as it had been in sixteenth-century Italy. Largillierre's pair of portraits of a socially ambitious husband and wife illustrates this as regards eighteenth-century France in very telling terms. The man, who only obtained his present well-paid job by marrying his wife, gloats in his impressive legal robes. His lady has gone to the length of compressing her charms into a handsome but inevitably very uncomfortable bodice. The somewhat smug image projected by the painting of the lady's face and costume is nevertheless very surprisingly negated by the words on a musical score she fingers with her left hand, those of a riotous drinking song for men. Both she and the sixteenth-century Italian girl, as portrayed by Bartolomeo Veneto, have put on every available stitch of finery in the form of silks and jewelry, recorded by Largillierre with extreme virtuosity and by Bartolomeo Veneto with touching literalness. The Italian girl seems not yet to have found a husband, but on the evidence of the portrait alone she is evidently sparing no pains to make good this deficiency.

The little watercolor by Gustave Moreau gives a good idea of the jeweled and scented world of this extraordinary artist whom Degas described unkindly as "the hermit who knows the time of the trains," and whose ivory tower art is in such extreme contrast with the outdoor world of his contemporaries, the Impressionists. This picture is known to have hung in Miss Anne Putnam's bedroom. This was strangely appropriate, as the Putnam sisters, like Moreau, were recluses. But it is due to their enlightened generosity, as well as to the munificence of the Timken Foundation, that the art world in general, and the people of San Diego in particular, have so much cause to be grateful.

Cecil Gould

1 Giovanni Antonio Boltraffio
Portrait of a Youth Holding an Arrow

oil on panel
19⅝ x 14 in. (49.7 x 35.4 cm.)

Born in Milan of noble family in 1467, Boltraffio entered the school of Leonardo in 1491. The latter mentioned Boltraffio in a note in his *Second Book on Anatomy*. Boltraffio remained with the master until c. 1498–99. In 1500 he went to Bologna where he painted a *Madonna and Saints* for the Casio family. He painted an altarpiece at Lodi in 1508, now in Budapest and, shortly thereafter, assisted in the fresco decorations of San Maurizio in Milan, where he died in 1516.

The young man represented half-length faces the spectator, his long golden hair bound by a fillet intertwined with laurel leaves, in his right hand an arrow. A jewel is pinned at the opening of his cloak.

When purchased by Lord Elgin, this portrait was described as "Portrait of François de Melzo, who appears here in the costume of Apollo, by Leonardo da Vinci." Not only was the attribution to Leonardo in error, but also the name of the sitter was dubious. A comparison with Boltraffio's presumed portrait of Melzo in the Heller Foundation, Bern, would indicate this. It has been suggested that the subject might be Girolamo Casio, a well-known Bolognese poet who was a close friend of the artist. Yet the features of the Putnam picture do not resemble in the slightest the portrait of Girolamo Casio, Brera Gallery, Milan (cat. no. 319). But our young man is closely related in features, costume, and general stylistic treatment to a portrait now given to Boltraffio called *Costanza Bentivoglio* (Suida, see references). It also may be related to the *Portrait of a Young Girl* by Boltraffio from the collection of Gianni Mattioli, Milan (see Los Angeles, Los Angeles County Museum, *Leonardo da Vinci, Loan Exhibition,* catalogue prepared by W. R. Valentiner, June 3–July 17, 1949, no. 43, pp. 23, 92, ill.).

The languid, somewhat androgynous Putnam figure suggests an allegorical theme rather than a realistic portrait. The genesis of the painting may be found in the silverpoint, *Head of Bacchus* (Accademia, Venice), probably by Boltraffio after a lost Leonardo drawing. Young men crowned with vine leaves or with other allegorical symbols are found in the drawings of Leonardo's circle.

In the Putnam painting the original *chiaroscuro* and subtle tonal gradations have doubtless been somewhat diminished by modern restoration.

A. M. and E. M.

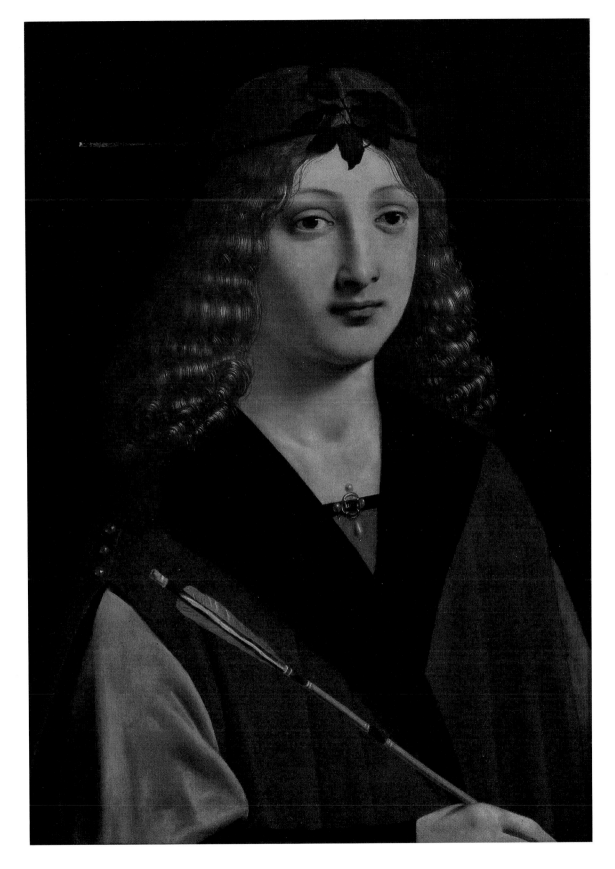

2 François Boucher
Lovers in a Park

oil on canvas
91½ x 76¾ in. (232.3 x 194.8 cm.)
signed and dated at lower right: F Boucher /
1758 (with the F. B. in monogram)

Boucher was born in Paris in 1703. He became a pupil of François Le Moyne and then of the engraver Jean-François Cars. He was awarded the Premier Prix of the Academy in 1723 and traveled to Rome four years later where he stayed until 1731. In 1734 Boucher was made a member of the Academy and then its director in 1756. He was appointed First Painter to the King, Louis XV, after the death of Carle van Loo. Boucher was associated with the Royal Tapestry Factories of Beauvais and Gobelins and designed for the opera. He served, too, as the drawing master of Madame de Pompadour. In 1770 Boucher died in Paris.

A girl, dressed in pale satins, gazes down, her thoughts withdrawn. Her left arm rests on the knee of a young man wearing a cherry-red coat over white linen. He places flowers in her hair and turns to look at a pretty maiden approaching from the background who carries baskets of flowers balanced at the ends of a stick across her shoulders. Behind them at the right are a pair of sculptured putti decorating the top of a ruined monument which is nearly masked by an overgrowth of vines, flowering shrubs, and trees. An alert little spaniel animates the right foreground.

Lovers in a Park is one of a series of five pictures by Boucher which formerly hung in Mentmore Towers, the estate of the Earl of Rosebery. All are signed and dated: *The Fisherman,* 1759, which is a companion piece to the Putnam picture; and three up-right panels, *A Girl and a Bird Catcher,* 1761, *A Girl with a Shepherd,* 1762, and *A Sleeping Girl and a Gardener,* 1762. The five paintings were sold at Sotheby's in March 1964. The identity of the original owner is not known.

In the last year of his life Boucher painted another set of pastorals which are part of the Iveagh bequest at Kenwood. They include a repetition of the *Lovers in a Park, A Man Offering Grapes to a Girl,* and a *Landscape with Figures Gathering Cherries.*

Just as Bernini represents the master *par excellence* of the Baroque, François Boucher was the embodiment of the Rococo or the style of Louis XV. He was perfectly suited by temperament to be what he eventually became in 1765: the First Painter to the King and, perhaps more important, the artistic mentor of La Pompadour.

Here in this characteristic picture one can see his palette with its delicious blues, pale grays, and reds which were derived from an artistic memory of Rubens and Watteau. The small rounded putti are a reminder of his work as a designer for the Royal Porcelain Factories. The placing of the figures, and their rather affected posturing, stem from his long and close association with *Opera Comique* and the ballet.

If Diderot and Grimm wished to denigrate Boucher's subject matter and even Goncourt, with all his extraordinary perception, could find something a little coarse in the artist's drawing, it is essential, as Fenaille pointed out, to seek to comprehend the man in his period and his ambiance. When Boucher painted for the Gobelins the *Rising of the Sun* and the *Setting of the Sun,* which Madame de Pompadour acquired (in the Wallace Collection, London), the figures were not the Olympians of Homer but the more frivolous deities of Ovid. Likewise, when Boucher turned to charming pastoral themes, such as this picture, his Annettes, as Goncourt said, did not stem from Theocritus but rather from Guarini. There was no reason for them to smell of toil, as Millet would have contrived. L'Abbé Bernis, a contemporary of Boucher's, savored more closely these droll puppets, wrapped in silk, and wrote with delicate feeling: "the light eternal chain which gently holds the shepherd to his love."
A. M. and E. M.

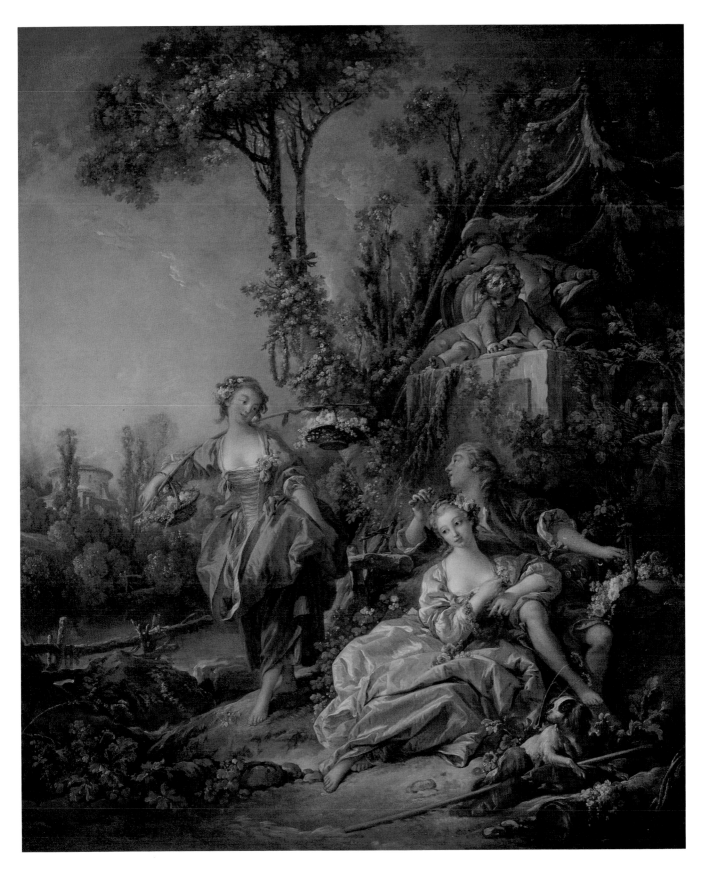

3 Pieter Bruegel the Elder
Parable of the Sower

oil on panel
29 x 40½ in. (73.7 x 102.9 cm.)
signed and dated lower right: Brueghel / 1557

Bruegel was born c. 1525, possibly in Breda. He was a pupil of Peter Coeck van Aelst in Antwerp, and in 1551 he was enrolled as a master in the Guild of St. Luke in that city. In 1553 he had traveled to Rome where he collaborated with the miniaturist Giulio Clovio. Bruegel then returned to Antwerp where he supplied drawings for prints which Hieronymous Cock published. In 1563 he moved to Brussels where he married and where he died in 1569.

In the left foreground, a peasant scatters seed on a small upland pasture. In accordance with the St. Matthew text, fowl are devouring the seed, thorns are flourishing, and there are stony places. Below to the right and in the middle distance near a chapel is the "good ground" where the seed has multiplied, thirty-, sixty-, and a hundredfold. A river flows diagonally from the right middle distance into a broad estuary. Three small boats are moored on the right bank of the river. Near the first one, a small crowd gathers to hear Jesus preaching. Further along on the right bank is a small fortified town on a hill; below, a little to the left, is a larger town dwarfed by Alpine crags.

The picture first came to notice when it was bought by Fernand Stuyck at public auction at the Fievez Gallery, Brussels, in 1924. It was then catalogued simply as Flemish School, seventeenth century. In December of that year, when it was cleaned by the elder Mr. Buesco, restorer for the Belgian royal family, the signature "Brueghel" and the date "1557" became visible. The painting came to the United States just before World War II. It was then shown in San Francisco and Washington. Two known replicas of the painting exist, both attributed to Bruegel. One was owned in 1932 by Cloots, the director of the Gallery Alice Marteau, Paris; the other is in the Prado, Madrid (no. 1964).

Friedländer considered this panel one of Bruegel's earliest signed paintings, done shortly after his designs for Cock in Antwerp. The drawings upon which the designs were based were made by Bruegel as he passed over the Alps on his return from Italy. They reveal the impact on the northern artist of both the heroic spirit of the Renaissance with which he became acquainted in Rome and the austere grandeur of the magnificent mountains. His northern eyes, with their inherited inclination toward detail and exactitude, looked with awe upon the scenes which his genius, broadened by his Italian experience, recorded in a series of drawings unique in their breadth and detail. From them came the etched landscapes which were published in Antwerp in 1555–57. A careful comparison of the Putnam picture with details in Bruegel's etched landscapes is revealing. Fortified hill towns situated on similar steep rocky bluffs are to be found in the *Plaustrum Belgicum,* the *Euntes in Emmaus,* and the *Magdalena Penitans* (see R. van Bastelaer, *Les Estampes de Pierre Bruegel l'Ancien,* Brussels, 1907, nos. 11, 14, and 8, respectively).

The aerial perspective of the painting, the sentiment of landscape, and the manner in which it is composed, all confirm the early date inscribed on the panel, a date before Bruegel's departure for Brussels. The subject matter is Bruegel's earliest treatment of the theme of a parable. Later he was to paint many.

A. M. and E. M.

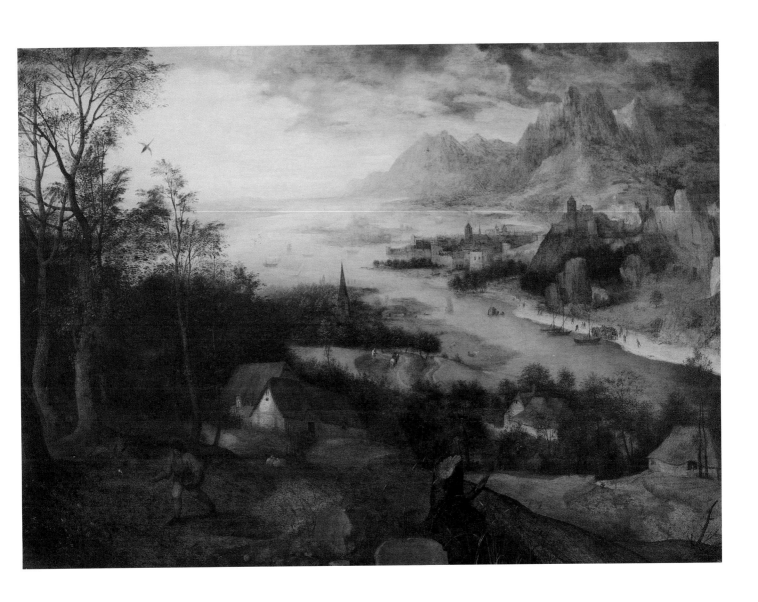

4 Guido Cagnacci
Still Life

oil on canvas
25⅞ x 19 in. (65.6 x 48.1 cm.)

The artist was born in Santarcangelo di Romagna in 1601. His name was Canlassi, but he was called Cagnacci. The latter was presumably originally some kind of joke. Canlassi means "leashes for a dog." Cagnacci means "mastiff dogs" (compare similar nicknames of Italian painters such as Botticelli, Tintoretto, and others). He was probably a pupil of Guido Reni while living in the Bologna area. He spent the last years of his life as court painter to the Emperor Leopold I at Vienna. Cagnacci was primarily a figure painter specially known for his titillating nudes disguised under such titles as the *Death of Cleopatra*. Until recently he was thought to have lived until 1681; he, in fact, died in Vienna in 1663.

A flask, filled with red and white carnations, rests on a pedestal. Its raffia wrap uncoils; a moth has alighted on a wayward strand. A second moth and two painted lady butterflies, wings spread, are poised near the blossoms. A rock lizard and a migratory locust can be seen at the base of the flask.

The fact that the straw is broken, that the flowers are withering, and that butterflies are notoriously short-lived may indicate a moral on the brevity of life in general. Such an allegorical reading could be considered confirmed by the fact that the livestock depicted are mutually destructive: the locust, and probably also the moths and butterflies, would eat the flowers, but the lizard would eat the locust.

The attribution of this picture to Cagnacci, though plausible, must stop short of total certainty owing to the lack of direct evidence. There are no pictures of this kind of subject signed by Cagnacci or vouched for as his work in documents dating from his lifetime. The most closely comparable pictures, namely, still lifes in the museum at Forlì, Italy, and in the Museum of Fine Arts, Boston, Massachusetts, and two formerly in the Leroux collection at Versailles and later (1964) in the Benedetelli collection at Milan, are themselves undocumented. The first three of these were included in the exhibition *La natura morta italiana* at Naples, Zurich, and Rotterdam in 1964 (nos. 42, 43, and 44), and, like the present picture, they show flowers in flasks whose straw covering is broken, the Forlì picture being in this respect closest to the present one.

A comparable bunch of flowers is included, in a jug in the top right corner, in a picture of a woman beating two dogs (collection of Prince Vitaliano Borromeo, Milan). Though this picture is itself undocumented, the type of the woman's face is fully characteristic of Cagnacci as shown in signed works such as the *Death of Cleopatra* (Kunsthistorisches Museum, Vienna). Though the Borromeo picture must therefore constitute the principal touchstone for the attribution of the present picture to Cagnacci, it might be argued that, just as Rubens himself did not usually paint the still life in such of his pictures as contained it but delegated this type of work to specialists in the genre such as Snyders, so the still life in the Borromeo picture need not have been Cagnacci's own work. Nevertheless, the fact that the Forlì picture was attributed by Arcangeli in 1952 to Cagnacci before he drew attention to the Borromeo picture in 1959 suggests that the latter *is* substantially the work of one hand—Cagnacci's—and tends to confirm the attribution to him of the present picture (see Rimini, Palazzo dell'Arengo, *Mostra della pittura del '600 a Rimini*, August–October 1952, catalogue prepared by F. Arcangeli, C. Gnudi, and C. Ravaioli, p. 33, pl. X; and Bologna, Palazzo dell'Archiginnasio, *Maestri della pittura del seicento emiliano*, April 26–July 5, 1959, catalogue prepared by F. Arcangeli et al, p. 149, ill.).

C.G.

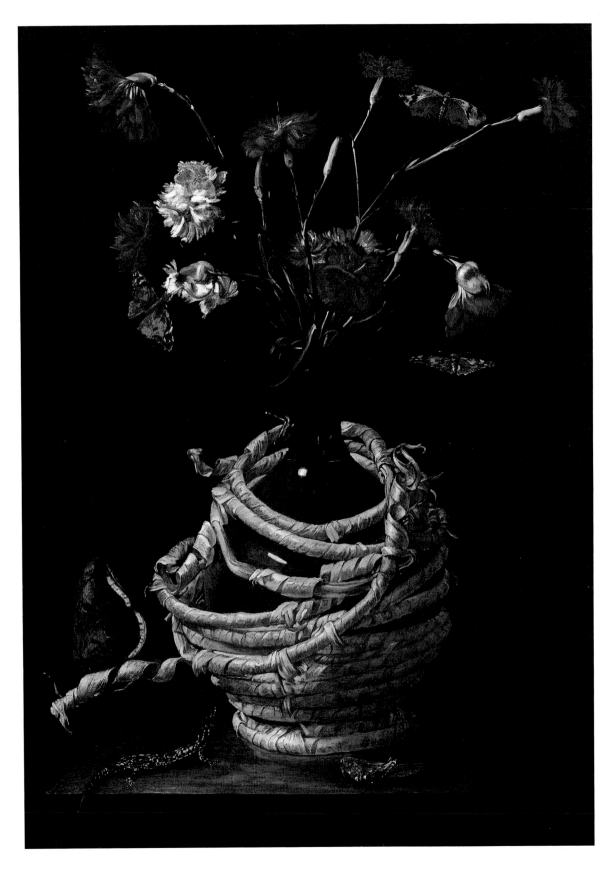

5 Luca Carlevarijs
The Piazzetta at Venice

oil on canvas
38 x 76⅞ in. (96.5 x 195.3 cm.)

Carlevarijs was born at Udine (Friuli) in 1663, but he lived and worked in Venice. He was thirty-four years older than Canaletto and forty-nine years older than Guardi. Therefore, he may count as the first specialist painter of the Venetian scene, though the Netherlander, Gaspar van Wittel, known as Vanvitelli, had painted a few Venetian scenes before 1700. Carlevarijs also published, in 1703, a book of etchings of Venice. He died in Venice in 1730.

The scene is the Piazzetta, looking north towards the Piazza of St. Mark's. On the left is the library, with part of the Campanile showing above it. Farther on is the side of the Loggetta and farther still, the clock tower partly obscured by the column of St. Theodoric. In the foreground to the right are seen the south side of St. Mark's, the Doge's Palace, and the column of St. Mark. The buildings shown, though not architecturally accurate in certain small details, are virtually unchanged to this day, but the wings which flank the clock tower were heightened in the mid-eighteenth century.

Aldo Rizzi pointed out that the fowl market was held in the Piazzetta on Friday mornings (see references). Though the present picture includes, in the center, a number of fowl cages, the market is not in progress, and the direction of the shadows—from the southwest—indicates that the time is afternoon. The market is therefore already over.

A similar view by Carlevarijs is in the Los Angeles County Museum of Art. An oil sketch which was apparently used by Carlevarijs for the figure in the center with his left foot on the lower step, his right elbow on his right knee, is included in the Carlevarijs sketchbook in the Victoria and Albert Museum in London (reproduced, Rizzi, fig. 43 of the Bozzetti section of illustrations, see references).

C. G.

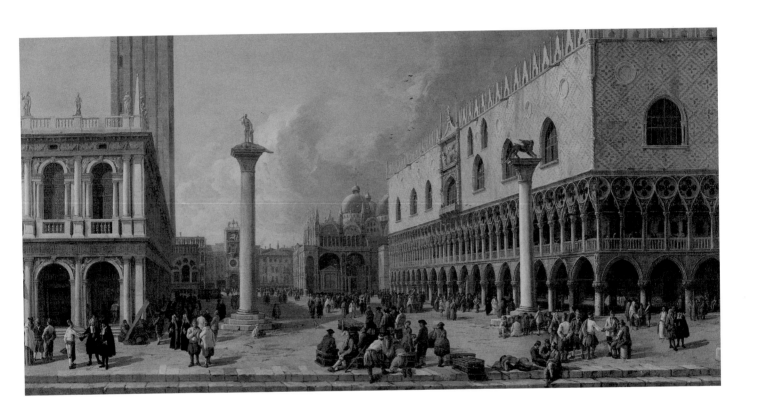

6 Paul Cézanne
 Flowers in a Glass Vase
 (Fleurs dans un Vase de Verre)

oil on canvas
16⅜ x 13⅛ in. (41.4 x 33.2 cm.)

Cézanne was born in 1839 at Aix-en-
Provence. It was there that he received his
early training. In 1861 he went to Paris
where he made friends with Pissarro and
others of the latter's circle. From 1863 to
1870 Cézanne divided his time between
Aix and Paris. In 1873 he moved to Auvers
and in 1874 worked near Aix. Cézanne's
first one-man exhibition was held in 1895,
but his success was not until the Salon
d'Automne of 1904 where a whole room
was devoted to his paintings. He died at
Aix in 1906.

This still life is an early work of Cézanne,
painted, according to John Rewald (letter,
January 1969), probably about 1872–73
(although Venturi dated it 1875–77, see
references). There are reminiscences of
Cézanne's early so-called "black manner,"
but even stronger is the influence of
Manet, whose brushwork and color har-
monies Cézanne is so clearly imitating
here. Cézanne's bright, clear colors and
intensely personal style, developed in isola-
tion and in southern sunlight, were still
a decade away when he painted this vase
of flowers.
 A. M. and E.M.

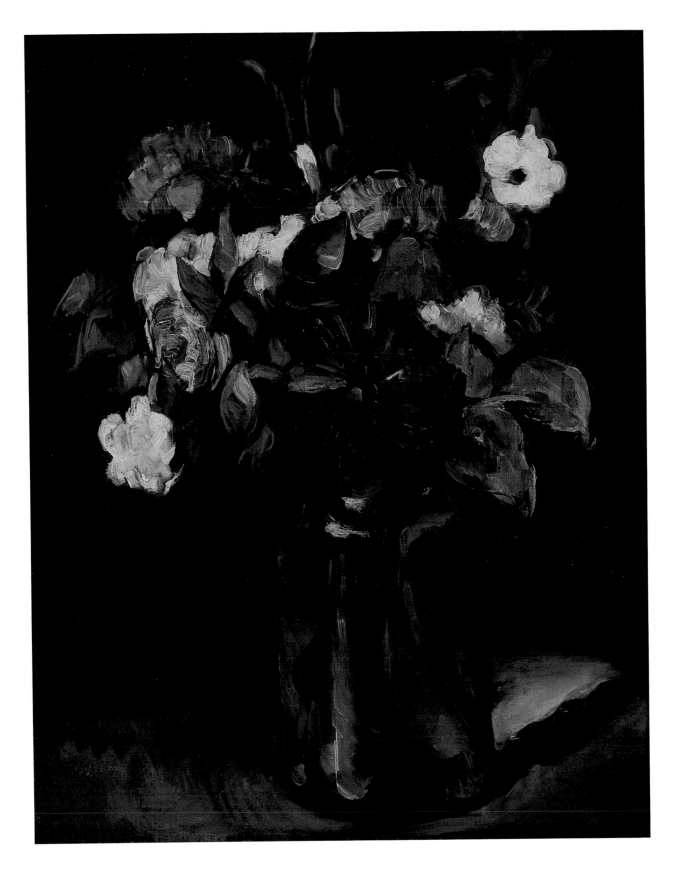

7 Philippe de Champaigne
Christt Healing the Blind

oil on canvas
40¼ x 55⅞ in. (101.9 x 141.9 cm.)

Champaigne was born in Brussels in 1602. He was the pupil of Fouquieres, then, in 1621, went to Paris where he worked with Lallemand. From 1622 to 1626 he painted landscapes for the Luxembourg Palace under the direction of Nicolas Duchesne. A friendship was formed with Poussin in 1623. In 1627 Champaigne returned to Brussels but went back to Paris in 1628. From 1634 to 1641 he worked for Richelieu and Louis XIII. In 1643 he came in contact with Port-Royal and the Jansenist Movement. Champaigne assisted in the founding of the Academie Royale de Peinture et de Sculpture. He died in Paris in 1674.

On a grassy mound over a grotto, the majestic figure of Christ, dressed in a violet robe with a blue mantle, stretches out his right hand toward two blind men who appear in the middle distance at the far left of the picture. A long procession, made up of apostles and followers, winds down diagonally through the foreground of the painting. In the middle distance is a broad river with a bridge which leads to a walled town. In the far distance to the right are imposing blue mountains.

Before the exhibition of the work of Philippe de Champaigne in the Musée de l'Orangerie in Paris in 1952, the painter was chiefly known for his solemn stately portraits and for his deeply religious paintings. However, a number of landscape paintings were included in that exhibition. In the words of Anthony Blunt, who reviewed the exhibition ("Shorter Notices," *Burlington Magazine,* 94 [June 1952]: pp. 172–75): "These paintings, which must date from the maturity of the artist, probably after 1648, show him using the classical convention of Poussin but with strong blue distances recalling the Flemish tradition."

This picture seems to have been influenced by Poussin's *Healing the Blind,* painted in 1650. Both follow Matthew 20:29–34, where Christ heals two blind men instead of one. Poussin's picture, painted for Reynon de Lyon, was in the collection of the Duc de Richelieu in Paris where Philippe de Champaigne could have seen it.

The fact that *Christ Healing the Blind* was in the artist's studio at the time of his death would suggest a date later than the landscapes included in the Paris exhibition, probably 1655–60. The elongated figures of the apostles, similar in proportion to a work begun in 1657 known only through a study drawing now in the Louvre (see F. Lugt, *Inventaire général des Dessins des Ecoles du Nord: Ecole Flamande,* 2 vols., Paris, 1949, l: no. 517, pl. XLI), would also support the later date.

The Counter-Reformation interpretation of the parable of Christ healing the blind, as an example of Christ cleansing the Church, must have had compelling attraction for an artist like Champaigne who was tied firmly to the Jansenist Movement.

A. M. and E. M.

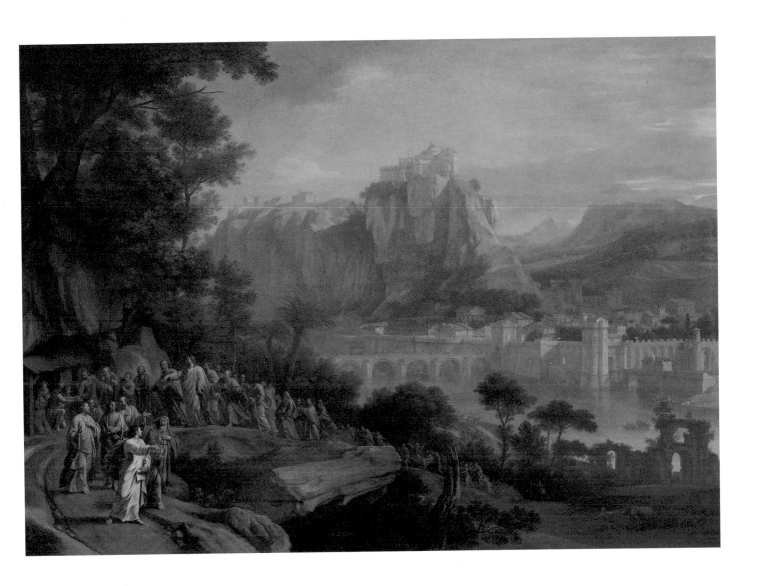

8 Petrus Christus
Death of the Virgin

oil on oak panel
65½ x 54⅛ in. (166.4 x 137.3 cm.)

Christus was born in Baerle, in Flanders, or North Brabant (the identification of the town not certain) c. 1410. He became a citizen of Bruges on July 6, 1444. Several of his paintings are signed in an abridged form, with Latin and Greek letters (Petrus xpi). Five or six of his paintings are dated between 1446 and 1452 or 1457. He was influenced by Jan van Eyck, the Master of Flémalle, Roger van der Weyden, and Dieric Bouts. During a supposed trip to Milan in 1457, he may have influenced the style of Antonello da Messina. Christus died in Bruges in 1472 or 1473.

The Virgin is lying stretched out on a canopied bed. Her soul, supported by five angels, ascends towards Heaven and is welcomed by God the Father supported by six angels. Eight apostles surround the bed. One looks out of the window; one advances into the room with holy water and aspergillum; one enters the door leaning on a staff. St. Thomas, seen through the doorway, looks up to receive the Madonna's girdle from an angel. In the right corner a closed book with a scroll marker rests on a three-legged stool.

Friedländer ascribed *Death of the Virgin* to Petrus Christus (see references). He marked its close relationship to *The Madonna and Child and Two Saints*, dated 1457, Städel Institute, Frankfurt am Main.

He noted that the painting had been in Sicily early in the sixteenth century, in the possession of the Santa Canale family, where it was once attributed to Antonello da Messina. A. Venturi reproduced the painting as by a Sicilian artist who had studied the work of van Eyck (see references). To Panofsky it was "unacceptable as a work by Petrus Christus" (see references).

The iconography of *Death of the Virgin* is a northern conception. An early example can be seen in the Franco-Flemish drawing, *The Death of the Virgin,* National Gallery of Art, Washington, D.C., Rosenwald collection (reproduced, A. Mongan, ed., *One Hundred Master Drawings,* Cambridge, 1949, p. 7). The theme continues to be a northern one. Some forty years later, it occurs in a woodcut published by Geeraert Leeu in 1487 in Antwerp, one that is very close to the style of the Timken panel (see Ludolphus of Saxony, *Thoeck vanden leven ons Heeren Iesu Christi,* facsimile ed., Antwerp, 1952, p. 138, ill.; Hain no. 10048). In 1518 Bernard Strigel painted a *Death of the Virgin* which was burned in a fire at Strasbourg in 1947. A copy of this painting was exhibited in Innsbruck in 1969 (see catalogue *Ausstellung Maximilian I.,* Innsbruck, 1969, no. 422, fig. 78).

It is possible that another version of *Death of the Virgin,* now lost, was known to Petrus Christus. There was also, formerly in the Laurent Meeus collection, Brussels, a panel of *The Descent of the Holy Spirit* in which the facial expressions of

two of the apostles and the porcelain cast of the Madonna's countenance are exceptionally close to the same figures in this San Diego picture (see Pierre Bautier, "La Descente du Saint-Esprit," *Mélanges Hulin de Loo,* Brussels, 1931, pp. 33–35, ill.).
A. M. and E.M.

A. Venturi's theory, referred to in the above entry, that this picture is the work of a Sicilian artist, is rendered improbable by the fact that the wood on which it is painted is oak. There is no doubt about this, and the fact that several scholars (listed by Sterling, p. 8, see references) have been misled into assuming it was on soft wood has undoubtedly contributed to their theories that the picture, if not the work of an Italian painter, at least might have been painted in Italy. In point of fact, the wooden support is a strong indication of a northern origin.

Since the Mongans' catalogue entry was written, attention has been drawn by several scholars (listed by Sterling, Gellman in *Simiolus,* and Collier, see references) that two wings, formerly in the Kaiser Friedrich Museum in Berlin but destroyed in 1945, representing SS. Catherine and John the Baptist, show continuity of landscape with the present picture as well as the same height. In consequence of this, there can be no reasonable doubt that they originally formed a triptych with it. They were likewise an oak.
C. G.

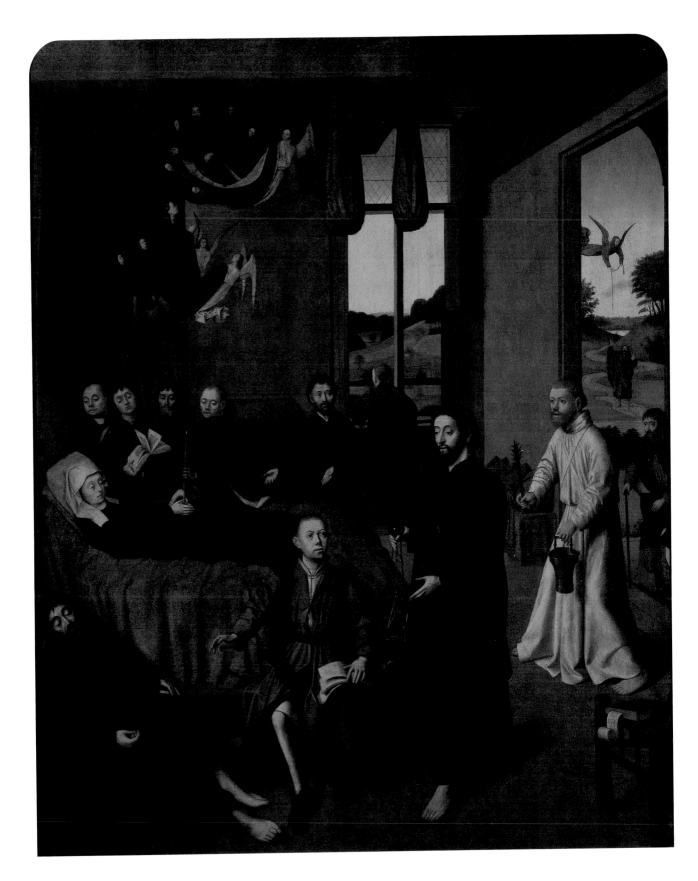

9 Pieter Claesz
Still Life

oil on oak panel
14¼ x 22⅝ in. (36.2 x 57.5 cm.)
signed and dated lower right: PC A° 1627
(with the P. C. in monogram)

Claesz was born in Westphalia in 1596 or 1597. He moved to Haarlem in 1617. The father of the landscape painter, Nicolaes Berchem, Claesz painted still life almost exclusively, displaying his originality in the form of effectively simplified compositions, usually consisting of only a few objects painted with considerable confidence and mastery in a subdued range of colors. He died in Haarlem in 1661.

The subject is a combination of the types known as "breakfast pieces" and "smokers' requisites" (see N. R. A. Vroom, *A Modest Message: As Intimated by the Painters of the Monochrome Banketje,* 2nd ed., Schiedam, 1980). It consists in this case of a pewter dish with two cooked fish, half a glass of stout, a knife, an overturned earthenware jug with the hinged metal lid open, a clay pipe, a small box for tobacco, a pot of burning charcoal, and a pile of tapers.

Before the seventeenth century, still life was not normally an independent branch of painting, though many large pictures of religious subject included vases of flowers or open books or other still-life subjects in the background or on a ledge in the foreground. One of the innovations of seventeenth-century Dutch painting was that instead of working exclusively to order, as had been the rule previously, artists now, in many cases, painted pictures of their own choice and then offered them for sale in the market. In these circumstances Claesz was able to spend much of his life devising different arrangements of domestic objects—often the same knives, jugs, and glasses. They are always painted with muted colors, and the different angles of the straight elements, such as knives or tapers, are contrasted with the curves of the glasses or jugs seen in perspective. This is well illustrated in the present picture.
 C. G.

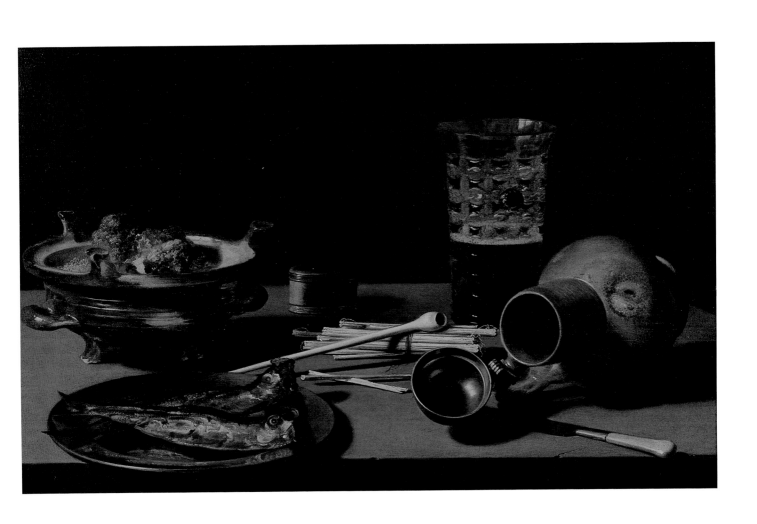

oil on canvas
40⅜ x 52¼ in. (102.4 x 132.5 cm.)

The artist was born at Chamagne, near Nancy, in 1600. His name was Claude Gellée, sometimes called Claude Lorrain and Claude Lorraine. While still a boy he went to Freiburg-im-Breisgau, and thence to Rome, as a pastry cook. He was employed in that capacity by the landscape painter, Agostino Tassi, and in that way gradually became a landscape painter himself. He spent the rest of his life in Rome, apart from a short visit to Naples and, in 1625–27, to his native village. The sketchbook which he called the *Liber Veritatis* (book of truth) was his own pictorial record of his paintings and was made to guard against imitations and forgeries. He died in Rome in 1682.

A woman kneeling in the left foreground is apparently drying the feet of a young shepherd, watched by a third figure. In the center foreground, a woman with a basket of clothes on her head follows a cowherd, who, with a dog, drives cattle, goats, and sheep across a ford. On the right, a rock behind large trees is surmounted by a ruined castle, to the right of which a waterfall descends through an arch. Another castle sits on a rock on the left in the middle distance. The long shadows and the pink tone of the clouds indicate the time of day as evening or early morning.

The Putnam painting is number 103 in Claude's record of his pictures, the *Liber Veritatis* (see above). Not all of the items are dated. Though neither the present picture nor the corresponding drawing in the *Liber Veritatis* bears a date, both can be dated to the period 1646–47, since the serial numbers in the *Liber Veritatis* are chronological, and the painting which corresponds with L.V. 96 is dated 1646 and the drawing L.V. 112, 1647.

The note on the drawing number 103 in the *Liber Veritatis* states that the corresponding painting—that is, the present picture—was painted for a patron at Avignon, which at that time was a papal possession. The same is stated for L.V. 104, of which the corresponding painting is now in the Hage Gallery, Nivaagaard, Denmark, and which may therefore be regarded as the pair to the Timken picture.

A pen, bistre, and wash study for the shepherd and the woman wiping his feet is in the British Museum, London (Hind, no. 236). An old manuscript note on the mount reads: "?Ulysses discovered by his Nurse." The two figures and dog crossing the ford as well as the rearmost cattle are included in a circular drawing in pen, wash, and heightening in the Morgan Library, New York. The landscape background has been telescoped. A companion drawing includes three of the figures in L.V. 104. Röthlisberger cites two otherwise unknown circular paintings by Claude which appeared in the Fonthill sale, 1823 (nos. 114 and 340). They are perhaps copies after which these drawings were made. In 1775, while the painting was in the possession of Sir Joshua Reynolds, an engraving after it was made by John Pye the elder.

C. G.

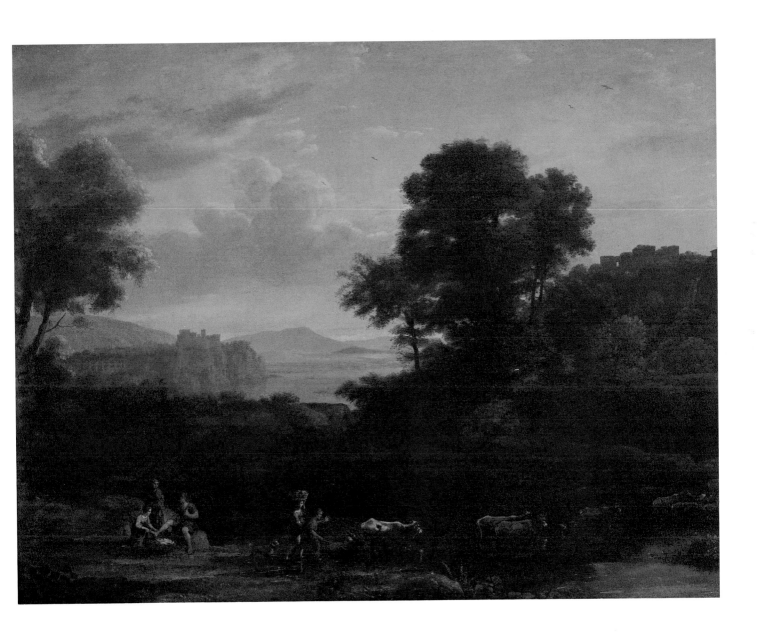

11 François Clouet
Guy XVII, Comte de Laval

oil on oak panel
12¾ x 9⅝ in. (32.2 x 24.4 cm.)

He was born c. 1522, probably at Tours, the son of Jean Clouet. In 1540 he succeeded his father as *Valet de Chambre* and painter to King Francis I, a post he continued to hold under Henry II, Francis II, and Charles IX. He died in Paris in 1572.

Laval, a young man with a serious, sober expression, is shown bust-length, facing three-quarters left, against a simple gray background. He wears a dark velvet suit embroidered in gold chain lines, a white turndown collar, and a cap with a short ostrich feather.

Comte de Laval, Montfort, Quintin, Comminges, Rethelois, Beaufort-en-Champagne, Vicomte de Rennes, Fronsac, Lautrec, St-Florentine, Sieur de Vitré, La Roche, St-Verain, Seigneur and Baron of Donzy, Orval, Coulommiers-en-Brie, and Lescun—to give him his full titles—was born at Vitry on February 14, 1522, the son of one of the great noble families of France. His mother was Anne de Montmorency, the sister of Anne de Montmorency, the Constable of France, who was the King's right-hand man. Comte de Laval was the only one of five sons who survived his father. So powerful were the Lavals that, through special privilege, each on coming into the title, as in a royal succession, assumed the name Guy. When Guy XVI died in 1531, the young man of this portrait, although he had been baptized Claude, assumed the name Guy XVII. A minor, he was brought up under the tutelage of two uncles, Anne de Montmorency, his mother's brother, and Jean de Laval-Chateaubriant, on his father's side. It was the latter who arranged Guy's marriage, at the age of thirteen, to another orphan of the same age who was also Chateaubriant's ward and niece, Claude de Foix, the daughter of Odet de Foix and Charlotte d'Albret. When Countess

Claude's brother Henri died in 1540, the Lautrec and de Foix patrimonies passed to the young Lavals. The Lavals had no children. The direct line of the Lavals died out with the death of Guy XVII at the age of twenty-five, some say from a sudden malady, others, from a stab wound. In spite of his standing he was deep in debt, many of the debts apparently inherited from his extravagant father. His widow sold her jewels and furniture to pay the debts before marrying, after only eight months of widowhood, the Count of Luxembourg, Charles de Martignes. The first child of this second marriage died. At the time of the birth of her second child, the mother and her newborn infant died when word was received of Charles's death in 1553 at the siege of Hesdin. This ended the direct de Foix and Lautrec lines. A drawing of Claude de Foix and a painting in the Louvre reveal that the Countess was somewhat hunchbacked.

This somber family history may explain why the portrait has been little known and without a name. It first appeared on the art market in the 1950s, the sitter unidentified. The identification was made by the present writer, who noticed its likeness to two sixteenth-century drawings, both with contemporary inscriptions calling him Laval: one at Chantilly (reproduced, E. Moreau-Nélaton, *Le Portrait à la Cour des Valois,* Paris, 1908, pl. CCXXIV), and one formerly in the collection of Philip Hofer, Cambridge, Massachusetts, now in an English private collection (reproduced, A. Mongan, "A Group of Newly Dis-

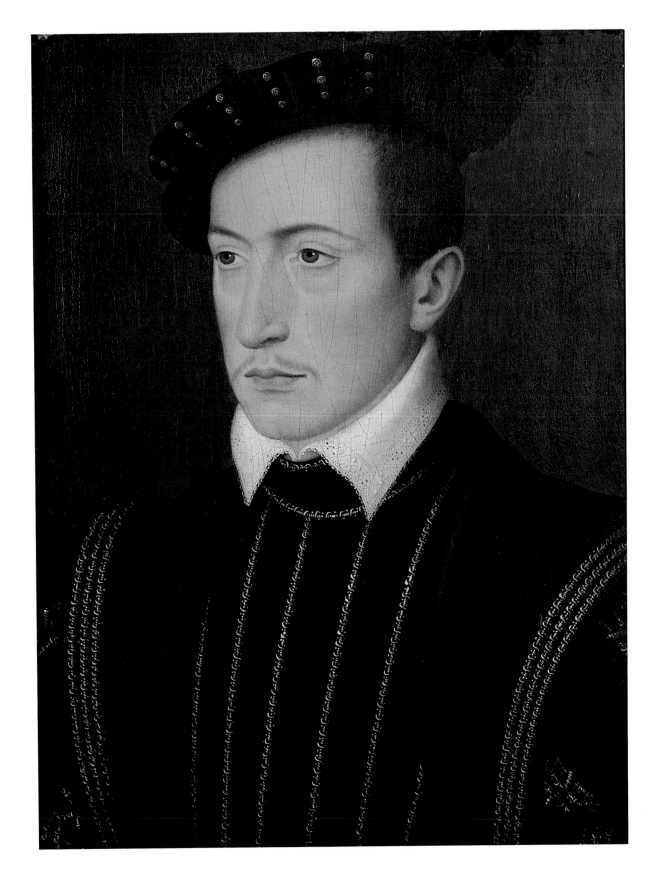

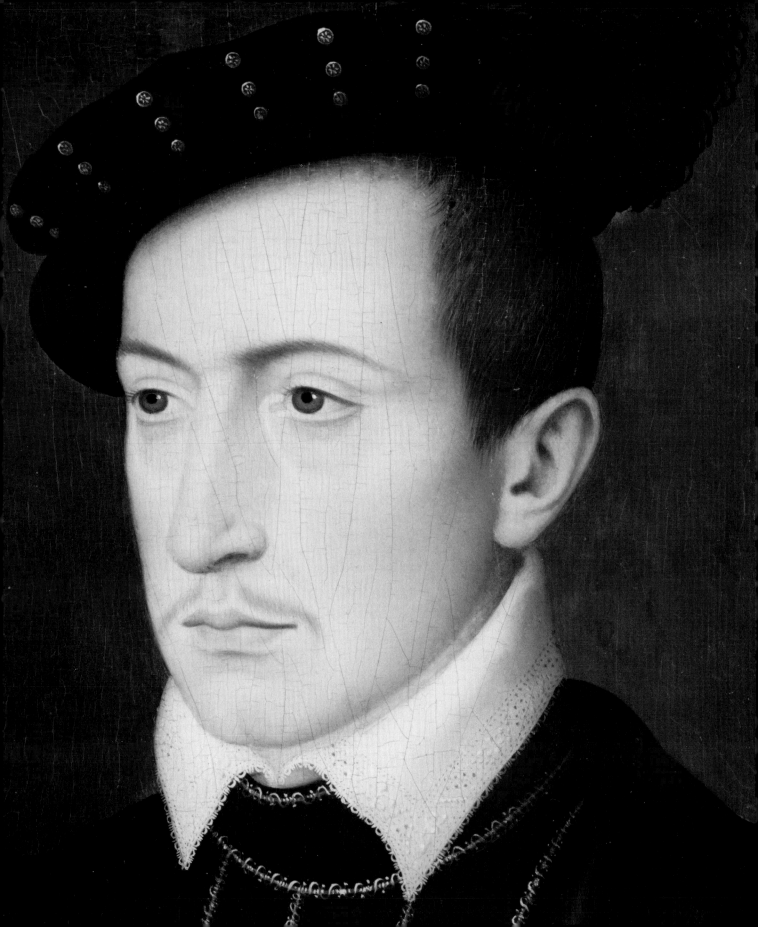

covered Sixteenth-Century French Portrait Drawings," *The Harvard Library Bulletin,* I [1947]: pp. 155–75, pl. V). The Chantilly drawing is described as representing Guy Laval at the age of eighteen.

We would like to suggest that the young man in the painted portrait is also about eighteen; that is, the portrait would have been painted in 1540. There seem to be strong reasons for assigning it to that year. Jean Clouet, who had been *Valet de Chambre* and *Peintre du Roi* died in 1540. François I appointed his son François to the posts his father had held. In the same year the King appointed young Laval (as well as his first cousin François Montmorency) a Gentleman of the Bedchamber of the King. By an act of the Royal Will on November 3, 1540, the King also declared that, although still legally a minor, Laval was to be declared of age and given control of his own affairs (A. Bertrand de Broussillon and P. de Farcy, *La Maison de Laval 1020–1605,* 5 vols., Paris, 1895–1903, 4 (1902): p. 108). The two acts of the King would place the youth close to the royal household and to its official artist, also newly raised to his royal office. The quality of the painting would bear out the attribution.

French court portraits of the mid-sixteenth century showed the sitters, elaborately but soberly dressed, bust-length against a neutral background. The features are recorded with exactitude and without flattery, but the sitters are withdrawn, as is this young man, in a world of their own thoughts. Later portraits by François Clouet show the artist more at his ease and more brilliant in both choice of color and technique. Here he is, at the outset of his distinguished career, somber in tone and earnest in interpretation.

A. M. and E. M.

12 Jean-Baptiste-Camille Corot
View of Volterra

oil on canvas
62⅝ x 47 in. (158.9 x 119.4 cm.)
signed and dated lower left: Corot . 1838

Corot was born in Paris, July 17, 1796, the son of a successful clothing merchant. He was sent to college in 1807 at Rouen, where he remained eight years. After eight more years in business, he turned to painting. A pupil first of A. E. Michallon, Corot then studied with J. V. Bertin. He was in Rome from 1826 to 1828, when he returned to Paris. Corot visited Italy again in 1834 and 1843. The artist made short visits to Switzerland, Holland, and England. He worked in Paris and in various provinces of France and died in Paris in 1875.

A solitary horseman is seen slowly ascending a sun-drenched road which winds between massive rocks. Stately trees on either side of the way are silhouetted against a brilliant sky. On the crown of the hill to the left, the Palazzo dei Priori is clearly visible. In the middle distance the valley of the Era lies at the foot of distant mountains.

During his second Italian trip in 1834, Corot spent some time in Volterra. There he made a number of sketches. The Putnam picture was painted in France from sketches that Corot had made in Italy.

Robaut, who illustrates this painting, states that it was perhaps the picture which Corot sent to the Salon of 1838 under the title of *Vue de Volterra*. It was indeed the San Diego picture which was exhibited and not the *View of Volterra,* National Gallery of Art, Washington, D.C., Chester Dale collection, with which it has been confused. The Washington painting is horizontal and is not really a view of Volterra but a landscape in the vicinity of Volterra. Robaut called the San Diego painting, *Cavalier gravissant une Montée rocheuse (Souvenir d'Italie).*

Corot, in one of his notebooks (Rome, c. 1828), wrote of his method of composition:

In preparing a study or a picture, it seems to me very important to begin by an indication of the darkest values (assuming that the canvas is white), and to continue in order to the lightest value. From the darkest to the lightest I would establish twenty shades. Thus your study or picture is set up in orderly fashion. This order should not cramp either the linearist or the colorist. Always (keep in mind) the mass, the ensemble which has struck you. Never lose sight of that first impression by which you were moved. Begin by determining your composition. Then the values—the relation of the forms to the values. These are the bases. Then the color, and finally the finish... It is logical to begin with the sky.

(Translation from Robert Goldwater and Marco Treves, eds., *Artists on Art: From the XIV to the XX Century,* 2nd ed., rev., New York, 1947, p. 240.)

A. M. and E. M.

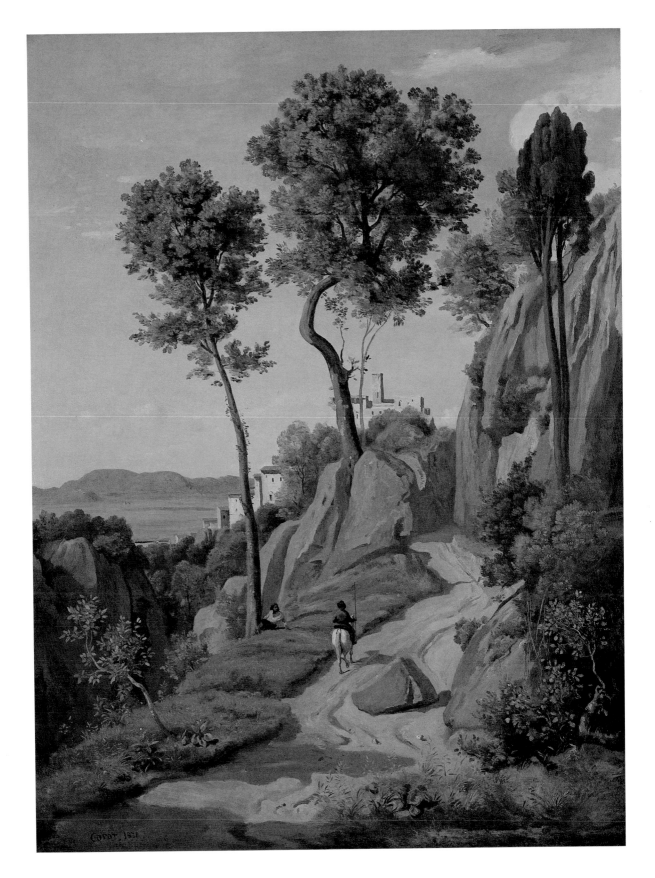

13 Jacques-Louis David
Portrait of Mr. Cooper Penrose

oil on canvas
51⅜ x 38⅜ in. (130.5 x 97.4 cm.)
inscribed at lower right: Louis David / faciebat /
parisiis anno / Xme / republicae Gallicae

David was born in Paris in 1748. He became a pupil of Vien in 1766. Having won the Prix de Rome in 1774, he remained in Italy from 1774 to 1779. *The Oath of the Horatii*, painted in Rome, was shown in the Salon of 1785. In Paris David became the founder in 1791 of a Neoclassical school which opposed the Academy. Active in the political events leading to the overthrow of the monarchy, he was commissioned to paint *The Oath at the Tennis Court*, 1790, and *The Death of Marat*, 1793. David was imprisoned after the fall of Robespierre but rallied to the side of Napoleon, whose official painter he became in 1804. He completed *Le Sacre* in 1809 and *The Distribution of the Eagles* in 1810. On the return of the Bourbons, David was exiled to Brussels where he died in 1825.

Cooper Penrose is represented life-size, three-quarter length seated in an Empire chair. He is dressed in a somber cutaway, with a white waistcoat and stock and dark knee breeches.

Louis David has suffered more than any other painter of his period from being what one might call a textbook personality. Just as plaster casts of the *Laocoon* and steel engravings of the *Baths of Caracalla* are part of the baggage of a classical inheritance, so *The Oath of the Horatii* and *The Death of Marat* are almost banal images in any history of French painting.

Until recently it has not been sufficiently emphasized that David was one of the great masters of portrait painting. Born with a natural capacity to seize a likeness, his long years of arduous training in Rome developed and refined his ability to draw. He posed his figures against dark backgrounds with so much taste and tact that the sense of reality is heightened, and the figures seldom appear mannered. They become living, memorable personages. Even Mr. Penrose's essential goodness and possible dullness are deftly suggested.

The Penroses originally came from Helstone in Cornwall; they are mentioned in the *Domesday Book*. In the seventeenth century one branch of the family migrated to Ireland. Cooper Penrose was born there April 10, 1736. He married Elizabeth Denis of Cork in 1763 and died in 1815. Cooper was a nephew of George Penrose, a famous glassmaker, and first cousin to William, George's partner; all belonged to Waterford. They were Quakers and formed an important section of the business life of that town, engaging also in the import and export trade. Cooper Penrose and his heiress wife settled in Wood Hill, an estate just outside Cork. Penrose enlarged the house to hold the art treasures he collected. At the age of sixty-three, in 1799, he went to France and was painted by David. A letter from David to Penrose (formerly attached to the frame of the painting; now in the collection of the Timken Art Gallery) outlined the terms of the commission:

> Let Mr. Penrose have complete confidence in me. I will do his portrait for the sum of two hundred gold louis. I will represent him in a manner worthy of us both. This painting will be a monument which will attest to Ireland the virtues of a good family man, and the talents of the painter who has painted it. There shall be three payments, that is, 50 louis at the start, 50 louis when the painting is sketched out, and the balance of 100 louis when the work is completed.

(Translation by Agnes Mongan)
A. M. and E. M.

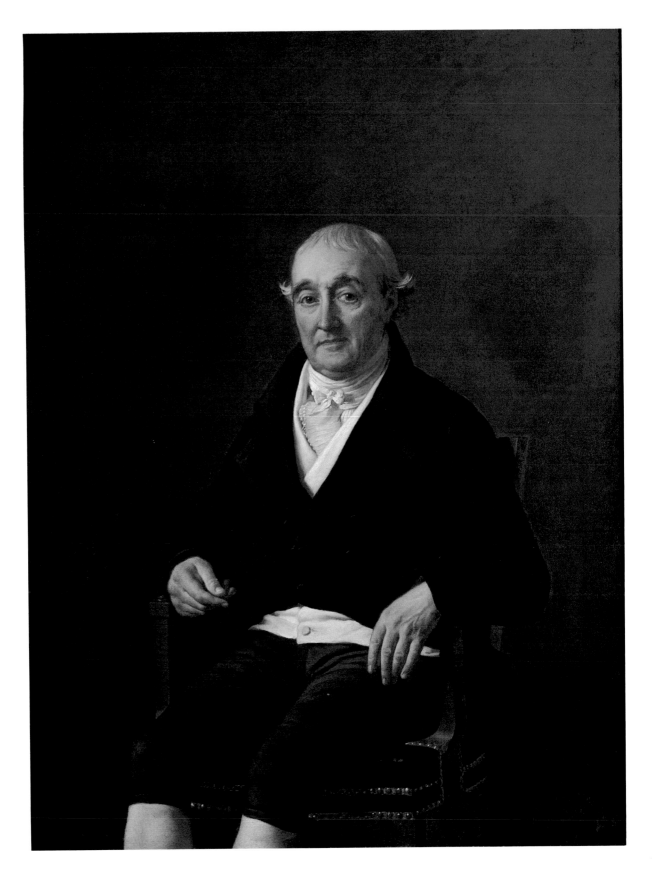

14 Jean-Honoré Fragonard
Blindman's Buff (Le Colin-Maillard)

oil on canvas
24⅝ x 17¾ in. (62.4 x 44.9 cm.)

Fragonard was born in Grasse in 1732, the son of a glover whose ancestors were of Milanese origin. As a child he was taken to Paris. Fragonard was the pupil first of Chardin in 1750, then, six months later, of Boucher. He studied also with Carle van Loo. In 1752 he was awarded the Prix de Rome. During his first stay in Italy from 1756 to 1761, he copied Old Masters, especially the Baroque painters. He traveled in Italy in the company of Hubert Robert and the Abbé de Saint-Non. In 1761 Fragonard returned to France and in 1765 was made an associate of the Royal Academy. A second journey to Italy from 1773 to 1775 was made in the company of the financier Bergeret de Grandcourt. During the Revolution Fragonard fled to Grasse. Later David appointed him as one of the first members of the Muséum des Arts. He died in Paris in 1806.

In the right middle distance, protected from the sun by a parasol, a group of children are playing blindman's buff. Diagonally to the left of them, a young woman holding a fan in her right hand is seated leaning against a balustrade. Just above her a young gallant, wearing a gray wig, faces out to the left with an expression of anticipation. To the right another woman, facing left, is seated under a large, spreading oak tree. A large oval fountain, dominated by a shadowy sculptural figure, is seen just behind the animated group. To the left below the fountain two other small figures are seen under another pink umbrella. In the upper left are traces of an architectural ruin almost hidden by dark thunder clouds.

The San Diego canvas was painted after Fragonard's return to France from his second trip to Italy, made with Bergeret de Grandcourt. In theme if not in scale, *Blindman's Buff* belongs to the same cycle as four large paintings in the National Gallery of Art, Washington, D.C., Samuel H. Kress collection: *A Game of Hot Cockles, Blindman's Buff, The Swing,* and *A Game of Horse and Rider.* However, in the San Diego picture, which is much smaller and probably painted later than the Washington panels (c. 1776), there is not only a difference in scale, but also a change in emphasis. In the Washington pictures the landscape, painted with large, sweeping views of park and sky, easily overshadows the small, elegantly clad figures seen playing at rustic games. In the more intimate San Diego painting the little figures merge into vibrant shrubs and are actually plasti-

cally supported by the gray masonry in a closely integrated composition.

Also, the game of blindman's buff seems rather a secondary theme. The adults in the picture are all looking intently not at the figure of a man whose eyes are blindfolded but at something outside the canvas to the lower left. Perhaps their attention is riveted on a troupe of itinerant charlatans or a puppet show, such as those in another masterpiece by Fragonard, the great *La Fête de Saint-Cloud,* painted about 1775, which has been in the Banque de France since 1808. It is well known that Fragonard, Robert, and Gabriel de Saint Aubin were fond of visiting and sketching at the popular fêtes at Saint-Cloud as well as more official parties at Rambouillet. It was from their sketches that the more ambitious watercolors and oils took form.

In this small masterpiece, painted in Fragonard's full maturity probably later than the Banque de France *La Fête de Saint-Cloud* and the National Gallery paintings, the great French master appears at the peak of his ability. The sunlight of the Rococo still pervades. The Revolution made an end of all such delicious pictures.
A. M. and E. M.

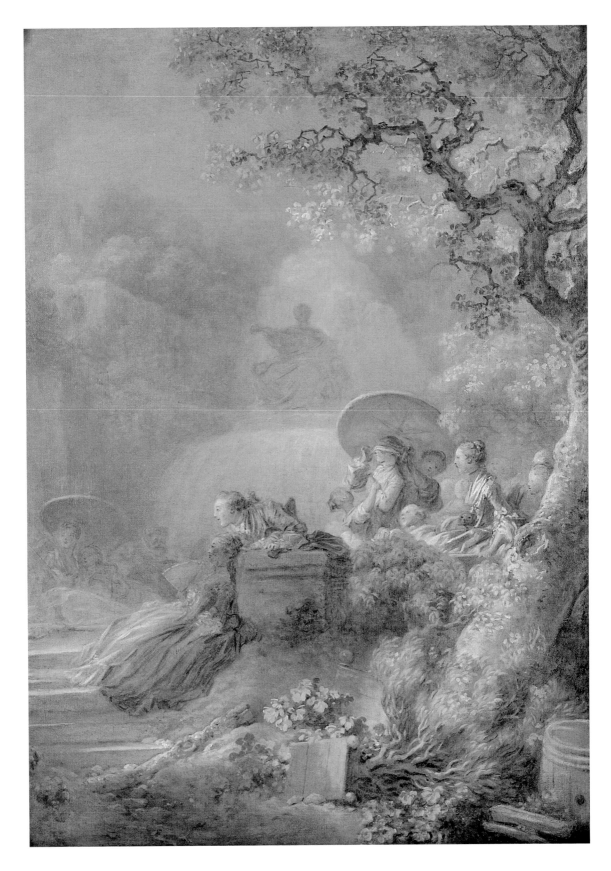

THE PETITION
186 x 94 in. (472.2 x 238.8 cm.)

THE REQUESTS OF THE CITIZENS
185 x 64 in. (469.9 x 162.6 cm.)

*THE QUEEN DISTRIBUTING
BOOTY*
183 x 93 in. (464.8 x 236.2 cm.)

A GROUP OF SOLDIERS
186 x 94 in. (472.2 x 238.8 cm.)

*tapestry of dyed wools and silks with gilt and
silver metallic thread*
Warp: 20 per in. Weft: 33–45 per in.

Artemisia, who lived in the fourth century B.C., was Queen of Caria, a part of modern Turkey on the east shore of the Aegean Sea. The primary source for her story is the Roman writer, Vitruvius. The tomb of her husband, King Mausolus, which she built at Halicarnassus, was the origin of the word "mausoleum." As a result of her energetic assumption of power following his death, she came to be regarded as the type of royal widow.

In this context a fanciful version of her story was written by a Parisian apothecary, Nicolas Houel, in a manuscript dated 1562 in honor of Queen Catherine de' Medicis,

widow of Henri II. It was accompanied by a large number of drawings by Antoine Caron and others, most of which are now in the Cabinet des Estampes of the Bibliotheque Nationale in Paris. A few tapestries were made from the drawings at the time, but most of those which survive, including the present four, date from after the establishment of the Gobelins factory in Paris at the beginning of the seventeenth century under the direction of the Flemings, Marc de Comans and François de la Planche. The parallel with Queen Artemisia again was applicable after the assassination of Henri IV in 1610 to his widow, Marie de' Medici, and yet again after the death of Louis XIII in 1643 to Anne of Austria.

The present tapestries bear the coat of arms of Victor Amadeus of Savoy, the monogram of Anne of Austria (A. M. for Anna Mauritius), the initials, F. M., of Filippe de Maecht, the head weaver of the Gobelins factory, and, under the latter, a flower identified as a pink, and finally the mark of the Paris workshop consisting of the letter "P" and a fleur-de-lys (the last not on *The Requests of the Citizens*). Anne of Austria did not come to France until 1615, and the weaver, Filippe de Maecht, left Paris for England in 1619–20. Victor Amadeus married Christina, the sister of Louis XIII (and sister-in-law of Anne of Austria) in 1618. The set was therefore very possibly ordered at that time as a wedding present from Anne to Victor Amadeus.

All four tapestries are adapted to fit narrow formats from wider compositions

known from the drawings and from other tapestries. Two of them—*The Queen Distributing Booty* and *A Group of Soldiers*—are actually parts of the same composition. The latter constitutes the extreme right-hand section. The soldier on the far left of this piece, with the curve of his shield partly visible over his right shoulder, is the same as the one on the right of *The Queen Distributing Booty*. In the full composition the Queen, instead of reaching with her right arm vertically downwards to a vase by her side—as she does in the present tapestry—extends it backwards to a tray held by a kneeling man. Of the other two tapestries, the composition of *The Petition* extends farther to the right in the complete version and includes a view of a garden. *The Requests of the Citizens* is also the extreme left-hand portion of another composition, in the center of which a seated man, evidently a provincial judge, is shown receiving the petitions.

Most of the other surviving tapestries of the Artemisia series are in palaces and museums in and around Turin. Though the immediate provenance of the present four is not traced, the presence of the coat of arms leaves no doubt that they are from the royal house of Savoy.

C. G.

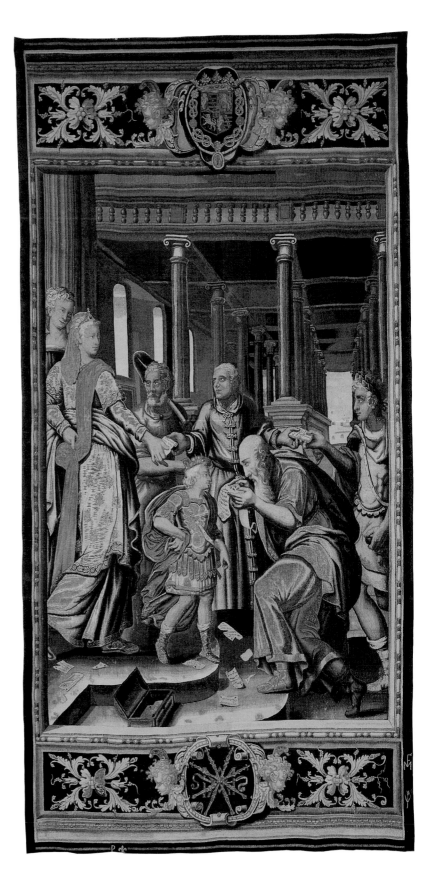

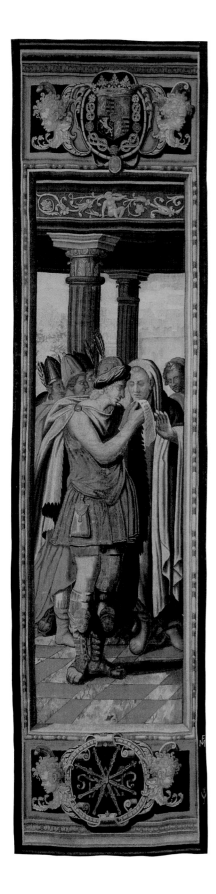

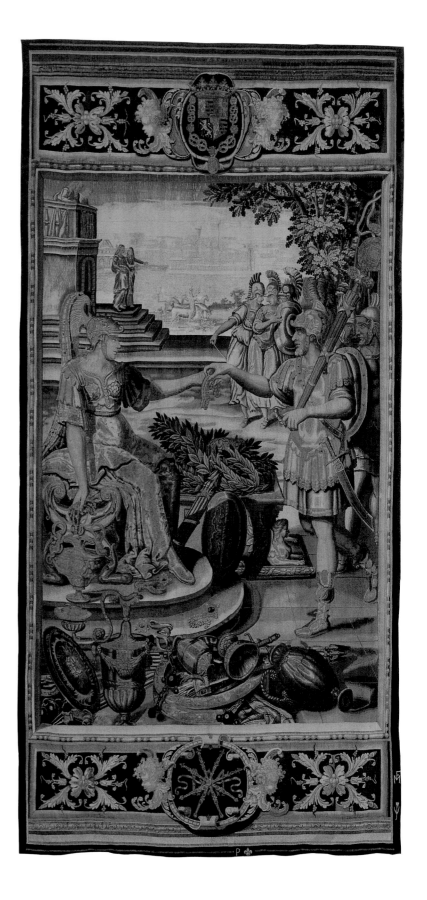

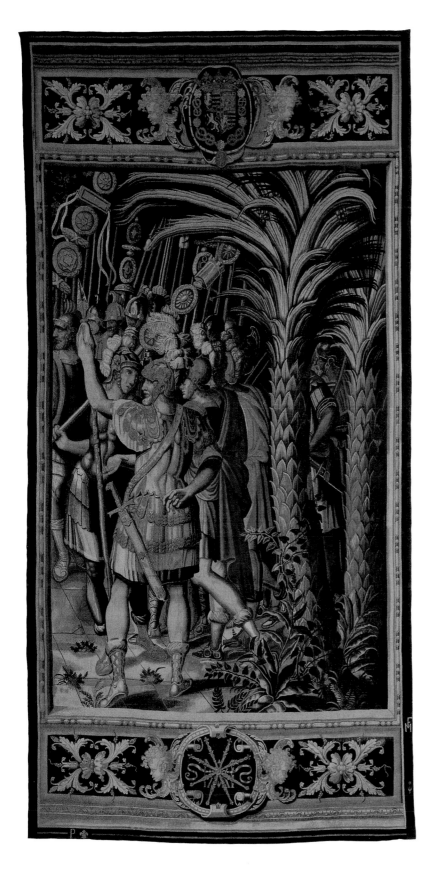

49

16 Frans Hals
Portrait of a Man

oil on oak panel
28⅞ x 22⅛ in. (73.5 x 56.2 cm.)
inscribed at upper middle right: AETA SVAE
48 / ANº 1634 / FH (combined)

Hals was born in Antwerp between 1581 and 1585, the son of a weaver from Mechelen. He was a pupil of Karel von Mander from c. 1600 to 1603. His first dated painting was a portrait of Jacobus Zafflius, 1611. The same year he enrolled as an associate of the Haarlem Society of Rhetoricians, "De wijn gaertranken"; his affiliation with the Society lasted until 1625. In 1644 he served as a member of the board of the St. Luke Guild of Haarlem. Hals painted René Descartes c. 1649. His famous group portraits are all now in the Frans Hals Museum, Haarlem. The artist was buried in St. Bavo's, Haarlem, in 1666.

A middle-aged man of slightly florid countenance with thinning hair and a light brown pointed beard is seen half-length, turned one quarter right, silhouetted against a gray-brown background. He wears a black doublet with a white pleated ruff, a dark mantle draped over his left shoulder. His right hand is raised to his breast.

This portrait, dated 1634, belongs to Hals's middle period. It was painted a year after the famous Company of St. Hadrian, Frans Hals Museum, Haarlem. It has been suggested that there is a companion piece, a Portrait of a Lady, inscribed "AETA SVAE 34 / ANº 1634 / FH." That portrait, formerly in the Oppenheim collection, Cologne, is now in The Detroit Institute of Arts (Hofstede de Groot, 3 [1910]: no. 380, p. 110, see references).

Seymour Slive, in Frans Hals, Exhibition on the Occasion of the Centenary of the Municipal Museum at Haarlem (Haarlem, 1962, p. 46), has noted the main characteristics of Hals's style in the thirties. In general the painter tended to a greater unity and simplicity in composition. The richly embroidered clothes of the previous period are replaced by the black regent costume. The silhouettes of the figures become more regular, and there is new restraint in the use of pictorial accents.

The overall somber aspect of the painting is relieved by the penetrating eyes and the ruddy complexion of this interesting personage whose identity remains unknown.

A. M. and E.M.

Eighteenth-century copies in watercolor (now in the Dayton Art Institute, Dayton, Ohio) of the present picture and of the companion portrait of a woman (now in Detroit) are inscribed as being after Johannes Verspronck (1597–1662). This is likely to be a copyist's error, as neither of the paintings resemble the style of Verspronck, nor is there any reason to question the authenticity of Hals's initials on the present picture.

C. G.

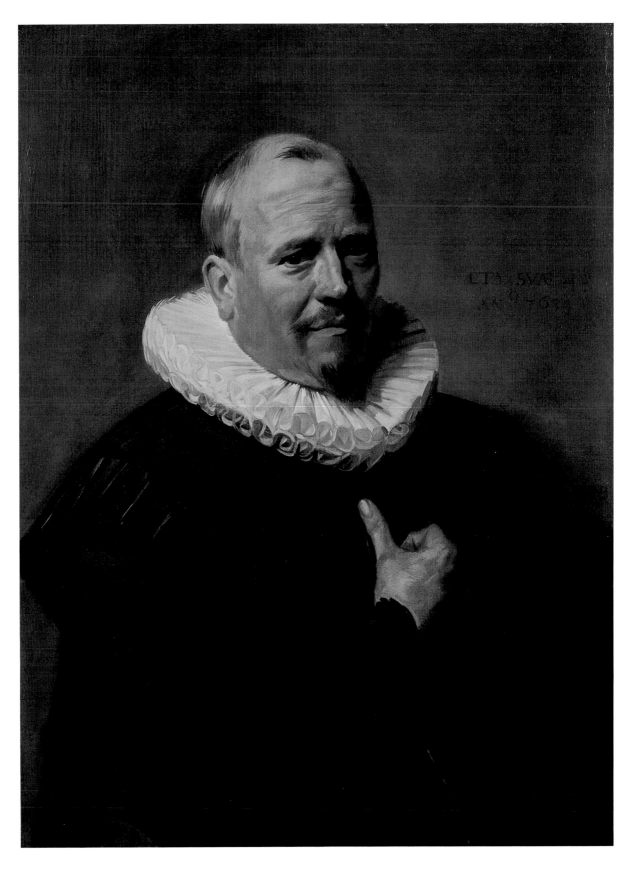

Nicolas de Largillierre
Portrait of Barthélemy-Jean-Claude Pupil

oil on canvas
54½ x 41⅞ in. (138.4 x 105.3 cm.)

His early career was exceptional. Largillierre was born in Paris in 1656, but he was brought up at Antwerp, and from 1674 he was an assistant to Sir Peter Lely in England. He was back in Paris in 1682. While his rival, Rigaud, portrayed the royal family of France, Largillierre had the patronage of the wealthy professional class. He died in Paris in 1746.

The bewigged sitter is shown at three-quarter length standing against a curtain. In his right hand he supports a large book, which rests on a console table. The second compartment from the top of the spine of the book is unornamented, unlike the other compartments, and was evidently intended to provide space for the title of the book. But the gilt of the lettering of the title has since worn away. Two smaller books lie on the console table; others are on the shelves behind.

Inscribed on the lining of the canvas on the reverse, evidently copying an inscription on the back of the original canvas, is the following legend: "peint par / N. de Largillierre. / .1729 / barthelmis. jean. claude. pupil. / chevalier. premier president. / de. la. cour. des monnoyes. / lieutenant. general. de. la. / senchausse. de Lyon." The sitter is shown in legal robes. The two appointments mentioned in the inscription quoted above, President of the Cour des Monnaies and Lieutenant Général of the Sénéchaussée of Lyon, were given to him immediately after his marriage in 1722 to Marguerite de Sève, the daughter of Pierre de Sève, who was the former incumbent of the Sénéchaussée of Lyon and whose family had filled this post for more than a century. Both of these offices were judicial. The former exercised jurisdiction concerning financial offenses; the latter was the judicial authority of a more general kind in the Lyon area.

The sitter is mentioned in the royal almanacs of 1742 (p. 213) and 1765 (p. 242). The latter specifies that his son, Barthélemy-Leonard, had succeeded him in the preceding year (1764) as President of the Cour des Monnaies of Lyon.

An engraving by Tardieu of the head and shoulders (in reverse) of what is apparently the present picture specifies the name of the painter as "Grandon." It is assumed that it was Grandon (?1691–1767) who painted the copy of the head and shoulders of the present picture which was used by Tardieu for his engraving.

C. G.

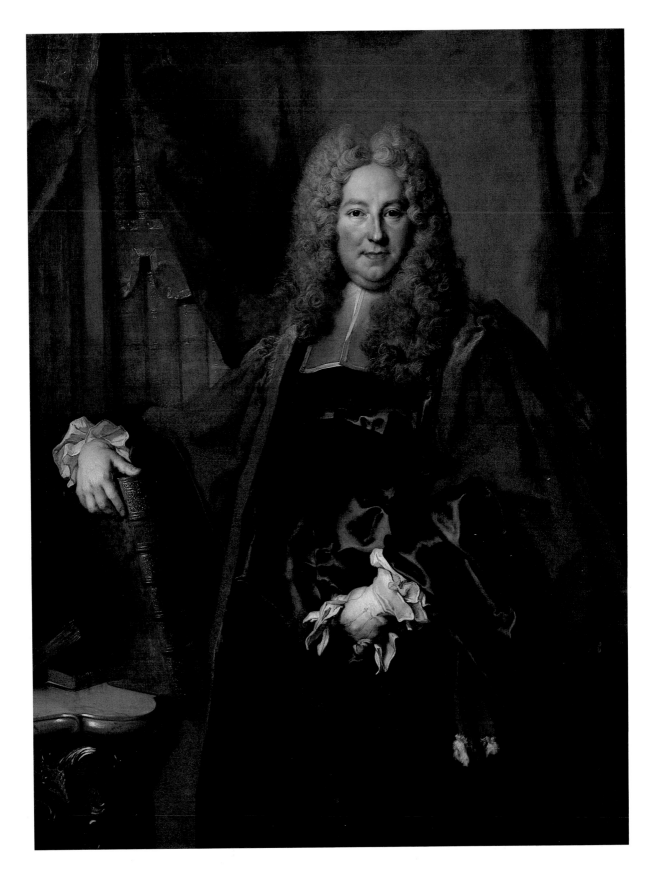

18 Nicolas de Largillierre
Portrait of Marguerite de Sève, wife of Barthélemy-Jean-Claude Pupil

oil on canvas
54⅝ x 41⅞ in. (138.6 x 105.3 cm.)

The lady stands at three-quarter length in front of a keyboard instrument. With her left hand she fingers the musical score which stands on a rest above the keyboard. Her right hand holds a furled fan. Inscribed on the lining of the canvas on the reverse, evidently copying an inscription on the back of the original canvas, is the following legend: "peint. par / N. de Largillierre. / .1729." For details of the sitter's marriage, which had taken place seven years previously, see the preceding entry.

A peculiarity of the sitter's costume is the embossed and jeweled bodice which reflects the lining of the sitter's robe and thus implies that it was made of metal. It has nevertheless been suggested that this effect could alternatively be given if the bodice were made of silk cut on the bias and mounted on molded buckram.

The music on the keyboard instrument on the right of the picture has six, not five, stave lines. It is therefore not music intended to be played on a keyboard instrument and appears to be for a lute or theorbo. Underneath, clearly legible, are the words of a drinking song: "Buvons beaucou [sic] mes chers amis. Buvons a la santé..." [Drink a lot, my dear friends. Drink to the health...].

M.-F. Perez has pointed out that the sitter's father, Pierre de Sève, had had his portrait painted by Largillierre's great rival, Rigaud (see references).
C. G.

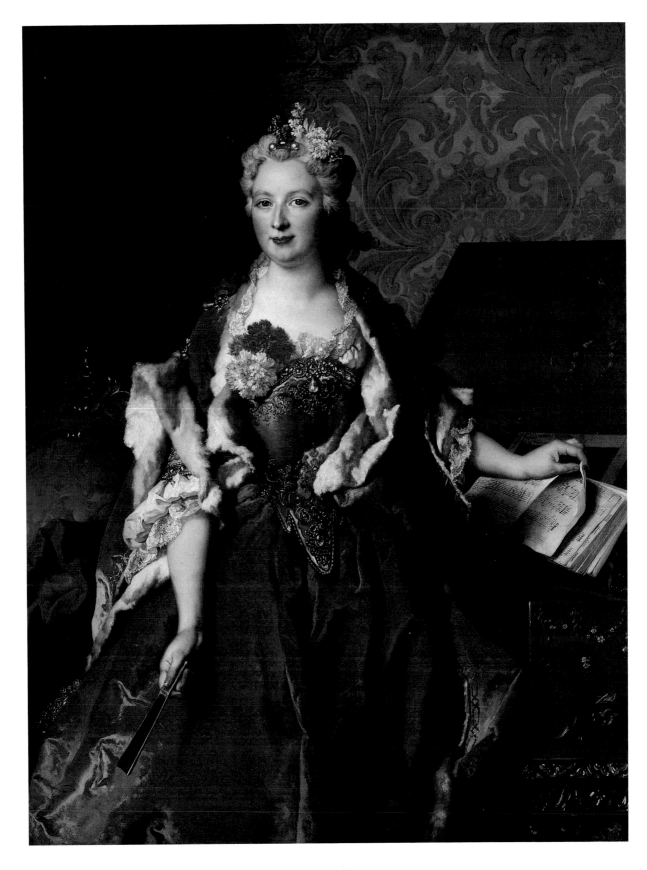

19 Luca di Tommè
The Trinity

tempera and gold leaf on panel
open 22⅜ x 21⅜ in. (56.8 x 54.3 cm.)

He was active from 1355 to 1389. Luca was influenced by Pietro Lorenzetti, Simone Martini, and Lippo Memmi. His name appears from 1355 through 1356 on the roll of the Guild of Painters in Siena. He was active in government, serving as municipal envoy to Orvieto in 1374. Luca was one of the most prolific and outstanding Sienese painters of the second half of the Trecento. Four of many paintings ascribed to the artist are signed and dated. In 1362 he signed with Niccolò di ser Sozzo Tegliacci the polyptych *Madonna and Child and Saints,* Pinacoteca, Siena. The *Crucifixion,* Museo Civico, Pisa; the polyptych of *St. Anne with the Virgin and Child on Her Lap,* Pinacoteca, Siena; and the altarpiece in the Museum at Rieti are signed and dated 1366, 1367, and 1370, respectively.

In the central panel of the triptych Christ Crucified appears against an image of the Trinity in a mandorla. St. Francis kneels at the foot of the cross, on either side of which stand the Virgin and St. John. In the gable above the central panel is the Resurrection. The left wing shows the Nativity and the Adoration of the Magi, surmounted in the half-gable by the Angel of the Annunciation bearing a banderole with the inscription: "AVE [MARIA] GRATIA PLE[NA]" (Luke 1:28). In the right wing, the Mocking of Christ and the Lamentation over His Body are surmounted in the half-gable by the Virgin Annunciate.

The Trinity is a remarkably preserved example of Sienese painting. The painter was clearly under the influence of Pietro Lorenzetti. The figures of the Annunciation at the top of the two gables are close to Lorenzetti's figures in his polyptych in the Pieve, Arezzo. The central mandorla is a personal device which Tommè had previously worked out in the *Assumption of the Virgin,* Yale University (reproduced, Meiss, 1951, p. 21, fig. 21, see references). The vibrant, enamel-like coloring emanates from the art of the miniaturists, indicating that Luca had learned much from his older associate Niccolò di ser Sozzo Tegliacci.

Meiss pointed out: "In view of the concern with doctrine and the exaltation of the Church and the Deity, it is not surprising that the Trinity should suddenly have become prominent in the iconography of the third quarter of the [fourteenth] century" (Meiss, 1951, p. 34, see references). Pope John XXII promulgated a doctrine on the Trinity in the early fourteenth century. Lauda or songs praising the Trinity were also current in the fourteenth century (F. Liuzzi, *La lauda e i primordi della melodia italiana,* Rome, 1935). Philippe Verdier comments: "The image of the Trinity is conceived as an abstract anthropomorphic composition, in some ways monstrous, since the Trinity is depicted as three identical persons furnished with a single body" (Verdier, p. 18, see references).

The Trinity was painted probably as a portable altar for a Franciscan prelate, as the small Franciscan monk in the foreground suggests. Actually for the iconography of his devotional painting, the artist need have looked no further than the explicit prayer in the Mass which follows the Washing of the Hands: "Receive, O Holy Trinity, this offering we present to you in memory of the Passion, of the Resurrection, and of the Ascension of our Lord Jesus Christ."

A. M. and E. M.

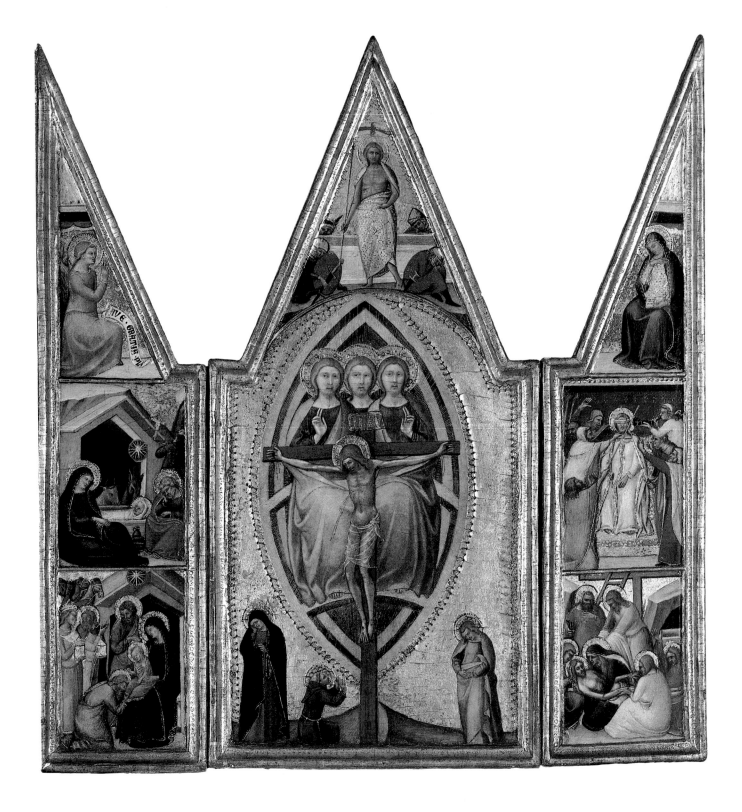

20 The Magdalen Master and the Master of San Gaggio
Dossal with Madonna and Child and Angels,
and Twelve Scenes of the Passion

LAST SUPPER
BETRAYAL
FLAGELLATION
MOCKING OF CHRIST
WAY TO CALVARY
CHRIST DISROBING
MOUNTING THE CROSS
CRUCIFIXION
DEPOSITION
ENTOMBMENT
THREE MARYS AT THE TOMB
NOLI ME TANGERE

tempera on panel
26¼ x 70⅝ in. (66.5 x 178.9 cm.)

The Magdalen Master, 1265–1290, was influenced in his early period by the Vico l'Abate Master, imitated Coppo di Marcovaldo, Melione c. 1270, and Cimabue c. 1280. He probably was the head of a shop of craftsmen, one of considerable historical importance. The painter who is called the Master of S. Gaggio was active in the latter part of the thirteenth century. Though tied to the late style of Cimabue, his works betray the influence of the young Giotto.

A damaged inscription on the back tends to confirm the internal evidence of the painting as Florentine. It states that Francesca Teresa Capponi Abbess (1705–1775) had the frame readjusted at her own expense, provided the two principals with silver crowns, and adorned the whole with glass ornaments. She was several times Abbess of the Augustinian Convent of Santa Maria dei Candeli, Florence, and the dossal may have been in that church from the time it was painted.

Our panel is of special importance since it is the only panel produced by two masters of a fairly high order at a critical turn in the history of Italian painting. The painter of the central figures derives his current name from a large figure of the Magdalen in an altarpiece in the Accademia, Florence (see catalogue by Luisa Marcucci, *Dipiniti toscani del secolo XIII,* 1958, no. 16). The primitivism of the Madonna recalls the famous *St. Francis* by Bonaventura Berlinghieri in Pescia, painted in 1235, but Offner considered this dossal a relatively late work of the Magdalen Master (see references). The elongated *Magdalen* of the Accademia and this Madonna contain intimations of a style that became familiar in fourteenth century Florence, one that is termed naturalism.

A. M. and E. M.

The figure of the Mary Magdalen in the Accademia altarpiece is flanked by small scenes which are comparable in style with the central figure in the same picture but which are considerably more primitive than the style of the small scenes which flank the Madonna and Child in the Putnam picture. For this reason it has been suggested—and most specialists have agreed—that two different masters were involved in the latter. The implication is not that one part was the work of a given master and the rest was that of his pupils, but that the picture passed at a given moment from the workshop of one master to that of another—an unusual event.

In the first edition of the present catalogue the painter of the small scenes was referred to as "an unnamed Florentine master." More recently, stylistic analogies have been traced with the work of a specific, but still unnamed painter. He is called the Master of S. Gaggio after another painting in the Accademia at Florence (no. 20 in the catalogue referred to above). This represents the Madonna and Child with SS. Peter and Paul and the two SS. John. It is reasonable to assume that the Master of S. Gaggio was responsible for the small scenes in the Putnam picture, presumably painted after the death of the Magdalen Master.

C. G.

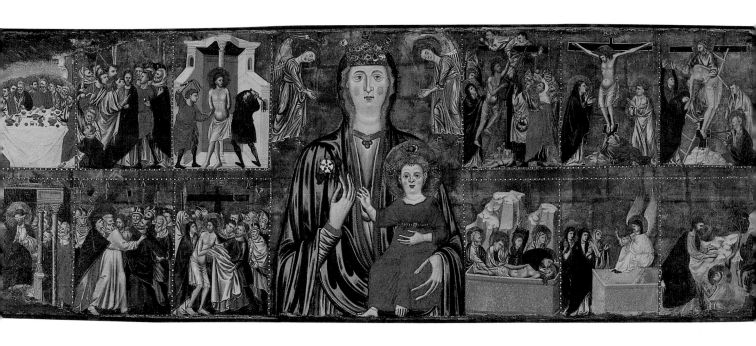

oil on oak panel
22⅞ x 17 in. (57.9 x 43.2 cm.)

The artist was active mostly in Bruges between 1475 and 1500. He was influenced by Memling. Possibly at the end of his career he was in Spain.

The Madonna is seated under a canopy with the nude Infant Christ reclining upon her knees. Before them kneels Caspar. His scepter and his black velvet cap, surmounted with his golden crown, lie on the ground near him. Behind him stands the bearded Melchoir, holding in his left hand his scepter and crown, and in his right a golden reliquary. To the right stands the black Balthasar wearing a jeweled crown, its points surmounted by crescents. A gold crescent hangs from an elaborate gold chain around his neck. The words "oobales oves" are inscribed in gold on the border of his skirt. In his right hand, he, too, holds a gold reliquary, in his left, a rock crystal scepter. Joseph watches intently from a doorway behind the Madonna. On the extreme left a shepherd peers at the scene. In the lower left corner is a strawberry bush, with flowers and fruit. At the upper right is a landscape with horsemen and the turrets of a walled city.

The Master of the Saint Lucy Legend is an artist who was first recognized as a distinct artistic personality by W. H. James Weale (*Gerard David: Painter and Illuminator*, London, 1895, p. 27). Friedländer named him after the artist's key work, *The Saint Lucy Legend,* in the Church of Saint-Jacques in Bruges, which bears the date 1480. Verhaegen has advanced the hypothesis that the Master of the Saint Lucy Legend may have been either a Spaniard who worked in Bruges or, more probably, a Bruges painter who finished his career in Spain (see Nicole Verhaegen, "Le Maître de la Légende de Sainte Lucie: Précisions sur son Œuvre," *Bulletin de l'Institut Royal du Patrimoine Artistique,* Brussels, 2 [1959]: pp. 72–82).

It is probable that the Master of the Saint Lucy Legend was familiar with Memling's *Adoration of the Magi,* now in the Prado, Madrid. The position of the Madonna, the personalities of the Magi, and even the characterization of St. Joseph, a civilized gentleman rather than a rustic, are very close to Memling's exposition. However, our Master has his own creative, individual talents. They are to be felt in the general composition of the picture: his placing the principal participants in a narrow space near the front of the picture plane; his bold juxtaposition of color, for example, green against bright blue; and the introduction of large areas of black for dramatic accent.

A noble theme, the Epiphany, is set forth with great dignity, with faithfulness to the legend, and with restrained realism. The predilection of the Flemish School for rich, exotic materials and glowing jewels is a reflection of the mercantile position of the Hanseatic towns. The elaborate reliquaries, each detail carefully observed, are a reminder of the importance of the goldsmith's art in many Belgian towns, such as Liège, Malines, Tongres, and Bruges.

A botanical sense, seen here in the delicious strawberry bush, was nurtured on familiarity with local manuscripts. Finally, there is a rather close relationship with the manufacture of tapestries, also a flourishing industry at the time.

Two other well-known paintings by the Master are in America: *The Virgin of the Rose Garden,* c. 1482, The Detroit Institute of Arts; and *Triptych of the Lamentation Over Christ,* The Minneapolis Institute of Arts. *The Adoration of the Magi* is an attractive example of Flemish painting at the end of the fifteenth century.

A. M. and E. M.

Though the attribution of the present picture to the Master of the Saint Lucy Legend has the powerful authority of Max Friedländer, the unknown, and therefore potentially changing, factors are such that this attribution can only be regarded as provisional. Not all scholars, for example, may agree that the Putnam picture is by the same hand as *The Saint Lucy Legend* triptych in Bruges, or that all of the pictures attributed to the unnamed painter of the latter by Friedländer are by the same hand. But until a more convincing alternative is worked out and published, it may be less misleading to retain the traditional attribution.

C. G.

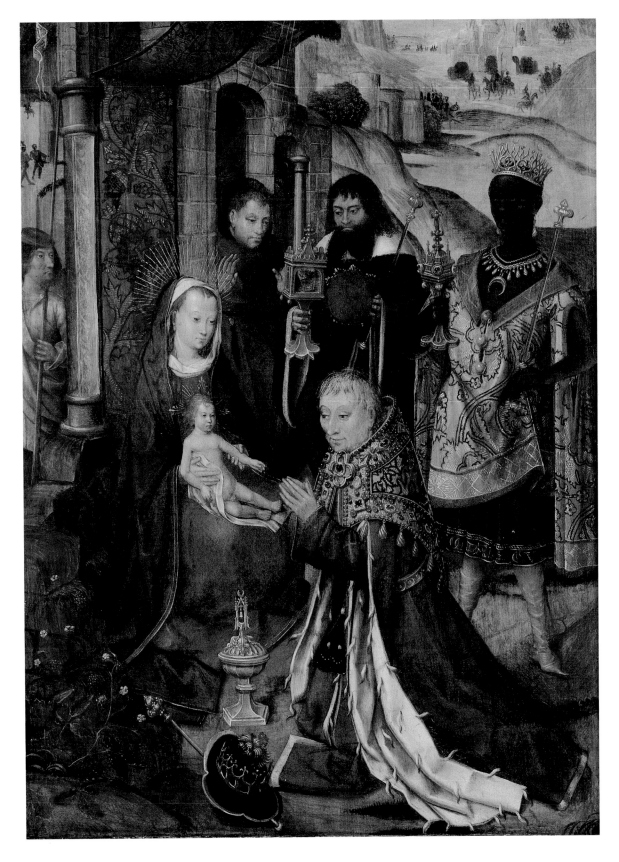

22 Gabriel Metsu
The Letter

oil on oak panel
10⅛ x 10 in. (25.7 x 24.4 cm.)
signed lower left: G Metsu (possibly a later addition)

Metsu was born in Leiden in 1629, the son of the Flemish painter, Jacob Metsu. He was said to have been a pupil of Gerard Dou. Metsu was a charter member of the Guild of St. Luke, which was established in Leiden in 1648. He lived in Amsterdam from 1657 until his death in 1667.

A young lady sits in profile to the left under a stone arcade. She wears a white cap and capelet, under which are seen her vermilion jacket and a pearl gray watered silk skirt. With her left hand she holds open a book, and with her right receives a letter from a solemn young messenger. To the left is a jardiniere filled with spring flowers. Behind the open arcade in the center is a Palladian villa and on the right an orchard.

The Letter is probably a pendant to *Man Writing a Letter,* now in the Musée Fabre, Montpellier. Both have the same dimensions and the same early provenance (Hofstede de Groot, see references). The pictures are painted in the loose, broad style which Metsu used in the middle and late fifties. Metsu repeated the theme about ten years later with two pendants representing a *Man Writing a Letter* and a *Woman Reading a Letter,* now in the Beit collection, Russborough at Blessington, Ireland.

It is possible that Metsu derived his material from Terborch, for example, *Officer Writing a Letter,* Narodowe Museum, Warsaw, and *Officer Reading a Letter,* Gemäldegalerie, Dresden, painted c. 1657–58 (see S. J. Gudlaugsson, *Gerard Ter Borch,* 2 vols., The Hague, 1959, 2: nos. 129, 130, pp. 143–44; 1: pls. 129, 130, pp. 288–89). In fact, the San Diego *Letter* seems very close to the work of Terborch, but the treatment of the young woman's profile, the drawing of the right hand, and the general color scheme are unmistakably characteristic of Metsu.

The theme was one for which Dutch artists in the seventeenth century had a special fondness. Further, Metsu's straightforward approach to genre, in which realism and objectivity were of the utmost importance, make a complicated iconographic intent appear foreign to his temperament. It seems doubtful that the flowers in the painting have any symbolic meaning. The subdued, quiet demeanor of the two solemn figures in *The Letter* may have overtones of sadness, but it is mainly the creation by the artist of a mood.

A replica of the San Diego picture is to be found in the National Gallery, Oslo. When the painting was still in the collection of Prince Auguste d'Arenberg, a lithograph of it was made in 1829 by L. Vandenberg (Spruyt, see references).
A. M. and E. M.

23 Gustave Moreau
The Herald at Arms (Le Heraut d'Armes)
or The Mace Bearer (Le Massier)

watercolor on paper
11¼ x 6 in. (28.6 x 15.3 cm.)
signed lower left: Gustave Moreau

Moreau was born in 1826 in Paris. He was in contact in his youth with Delacroix, if not actually his pupil. He was also greatly influenced by Chasseriau. Moreau traveled to Italy in 1841 and in 1857–59, but resided primarily in Paris. He was much admired by the French Symbolist poets who considered Impressionism to be "lowbrow" art. Having private means, Moreau had no need to compromise in his art. He died in Paris in 1898.

The figure, elaborately dressed, is seen from the front on a richly caparisoned horse against a wall covered with heraldic tiles. In his right hand, he holds a heavy staff with a small pennant at the top.

The title is that of a picture shown by Moreau at the Universal Exposition in Paris in 1878 (Mathieu, no. 178, see references). According to the exhibition catalogue, the latter watercolor was larger (24¾ x 13⅜ in.) than the present one, which is evidently an autograph replica. The other picture (Mathieu, no. 178) included a tall arch in the background.

C. G.

24 Bartolomé Esteban Murillo
Christ on the Cross

oil on canvas
82¼ x 44½ in. (208.8 x 113.2 cm.)

Murillo was baptized in Seville January 1, 1618. Orphaned at the age of ten, he entered the studio of Juan del Castillo in 1630. He was influenced when young by both Zurbarán and Ribera. In 1645–46 he painted eleven pictures for the small cloister of the Franciscan monastery at Seville. Murillo established permanent residence in Madrid in 1658. From 1646 to 1660 he was influenced by the Flemish and Venetian paintings in the royal collections of Castile. According to tradition he fell from a scaffold while working for the Capuchins of Cádiz. He was brought back to Seville where he died in 1682.

The luminous figure of Christ extended on the cross is seen against a dark, ominous sky. An inscription at the top of the cross reads in Hebrew, Greek, and Latin variations: "Jesus of Nazareth, King of the Jews." Below at the left in shadowy mists are discernible the outlines of the city of Jerusalem. In the foreground lie the skull and tibia of Adam, faintly touched with ochre color.

The work of Murillo is generally divided into three periods: his early manner, which is characterized as cold in color and rather dry; his middle period, called warm because of his palette; and his late style, known as misty or dark. Mayer has placed the *Christ on the Cross* in Murillo's last period, which is dated from 1660 to 1670. In his introduction he noted that Murillo painted few authentic pictures of the Passion of our Lord (see references). He mentioned this *Christ on the Cross* and two others, one in the Prado, Madrid, and the second, *St. Francis of Assisi Renouncing the World* (Embracing the Cross), in the Museo Provincial de Bellas Artes, Seville. All are very close in their representation of the Crucified Christ. The Putnam picture is closely related to the Prado *Dead Christ on the Cross*. Here, however, Christ has not yet died.

Pierre Paris (*La Peinture Espagnole,* Brussels, 1928) has clearly outlined the difference in Spanish mysticism between the religious paintings of Murillo and the visions of El Greco. In Murillo, the figures and setting represent the material world which the monks and prelates of the seventeenth century wanted for their altars. Here Murillo has surpassed himself by painting a transcendent image of the Man-God in his own Sevillian terms of Spanish Counter-Reformation understanding.
A. M. and E. M.

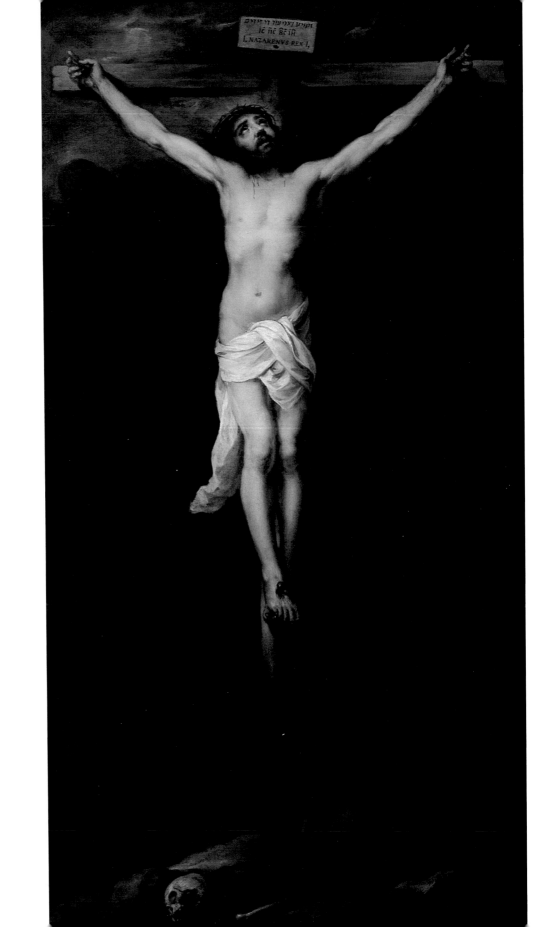

25 Niccolò di Buonaccorso
Madonna of Humility with Saint Catherine and Saint Christopher, the Annunciation, and the Crucifixion

tempera and gold leaf on panel
open 25⅞ x 21½ in. (65.6 x 54.6 cm.)

Niccolò is first mentioned as a municipal councilor in Siena in 1372. He was elected *Gonfaloniere* of the Terzo of S. Martino in 1381. He worked for the Duomo in 1376 and in 1383 and died in 1388.

The Madonna is seated on the floor in front of a marble bench, holding the Child on her right knee; above is the Crucifixion with Mary and St. John, with St. Francis embracing the cross. In the half-gables, left and right, are the Angel Annunciate and the Virgin seated on a cushion. On the left wing stands St. Catherine of Alexandria wearing a crown, a book in her right hand, a palm in her left, her left arm resting on the wheel of her martyrdom. On the right is St. Christopher holding the Christ Child who points to a globe held in His left hand.

This triptych was first published in the Walters' exhibition catalogue, *The International Style* (see references). The attribution to Niccolò di Buonaccorso was based on the similarity of the central panel to a picture which Berenson described in 1931 (see Bernard Berenson, "Lost Sienese Trecento Paintings—Part IV," *International Studio*, 98, no. 404 [January 1931]: p. 29, fig. 2). The St. Christopher on the right wing and the Annunciation in the half-gables are closely related to similar figures in a triptych in, or formerly in, the Castle of Konopiště, near Prague, which Meiss recognized as a work by the artist. A personal mannerism of Buonaccorso's was the painting of the whites of the eyes as little round dots of white. In the central panel the Madonna's mantle is suffused with a dynamic circling rhythm that, in its silhouette, echoes the arc of the gold background.

It has been difficult sometimes to distinguish the hands of the two artists, Buonaccorso and his contemporary, Paolo di Giovanni Fei. Both derived from Ambrogio Lorenzetti. Accepted authentic works by Niccolò include: a signed panel, *The Marriage of the Virgin,* National Gallery, London; painting signed and dated, 1387, in the Chiesa di S. Margherita near Siena; and a *Coronation of the Virgin,* Metropolitan Museum of Art, Robert Lehman collection, New York.

The source for this iconography was the *Mirrour of the Blessed Life of Jesus Christ* written by the Pseudo-Bonaventura, a book composed in the late thirteenth century by a Franciscan monk for the benefit of a nun in the order of St. Clare (translated by N. Love, Roxburghe Club publication, Oxford, 1908).

The charming, intimate details—the open book on the cushion, a stand for bobbins, the tricot, and the knitting needles—were all fresh introductions to the theme made in Italy in the late fourteenth century. The homely additions to the sacred story are infused with what Mâle has termed "Franciscan sensibility." The little narrative touches are quite secondary to a quality of mystical grace of the piquant Madonna. Here is one important aspect of Sienese art at the end of the fourteenth century: the "Franciscan sensibility" interpreted with refinement.

A. M. and E. M.

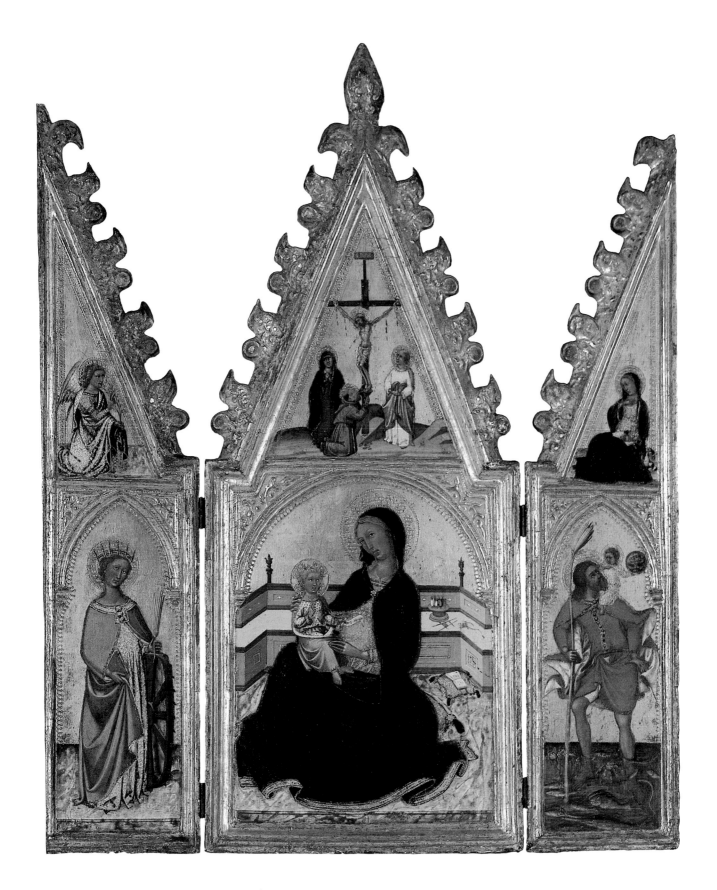

26 Rembrandt Harmenszoon van Rijn
Saint Bartholomew

oil on canvas
48⅜ x 39¼ in. (122.7 x 99.5 cm.)
signed and dated lower left: Rembrandt / f. 1657

Rembrandt was born in Leiden, July 15, 1606. He enrolled at the University of Leiden in 1620. He was a pupil in the atelier of Jacob Isaacsz. van Swanenburgh in Leiden, 1621–24, and next became a pupil of Pieter Lastman in Leiden for six months, 1624–25. In 1632 Rembrandt moved to Amsterdam where he remained to the end of his life. He died on October 4, 1669, and was buried in the Westerkerk.

The apostle sits in an armchair, his body directly facing the spectator, his head slightly turned to the left. His face is framed in black curly hair and a dark beard. He wears a plain brown coat with a white cuff showing on his right wrist; a thick cloak falls over both knees. In his right hand he holds a knife, the symbol of his martyrdom. At one time the knife was repainted and changed into a book. About 1912, when the painting was cleaned by Professor A. Hauser, restorer of the Berlin Museum, it was discovered that St. Bartholomew held a knife and not a book.

This painting may have belonged to a series of apostles which seems never to have been completed. It is now generally agreed that the *St. Paul,* National Gallery of Art, Washington, D.C., Widener collection (Bredius, no. 612), represents a companion piece. Both paintings are signed and dated 1657. Both picture the saints three-quarter length, and both have approximately the same dimensions.

Rembrandt was deeply concerned throughout his life with the theme of holy men. It is not always easy to disentangle the prophets from the apostles or to fathom Rembrandt's exact intent in each painting, especially when some only lightly conceal a portrait under dark clothes. It has been suggested that Rembrandt took as models for some of these spiritual paintings Jewish men then living in Amsterdam. He wished perhaps to emphasize in his very personal interpretation of great Biblical figures something exotic and mysterious, remote from ordinary Dutch life. They are all seers or prophets whose force comes from within.

In the *St. Bartholomew* the extraordinarily skillful management of light contrasting with the large dark masses and the use of thick impasto strokes heighten the overall expressive nature of his representation. The quality of the brushwork in the San Diego picture seems to illuminate the character of this lonely figure, a man who might be classed with those who longed to walk with God.

A. M. and E. M.

27 Peter Paul Rubens
Portrait of a Young Captain

oil on oak panel
25½ x 20 in. (64.6 x 50.6 cm.)

Rubens was born at Siegen, Westphalia, in 1577. He studied under Tobias Verhaegt, Adam van Noort, and Otto van Veen. Entering the service of Vincenzo Gonzaga of Mantua, 1600–1608, he lived at Mantua, Rome, and Genoa. His first visit to Spain occurred in 1608. He returned to Antwerp in 1609. Rubens was appointed court painter to the Brussels court of the Archduke Albert and Infanta Isabella. He visited Paris, 1622–25, and painted the Marie de' Medici cycle for the Luxembourg Palace. His second visit to Spain was a diplomatic mission in 1628. He visited London as envoy to Charles I, 1629–30. The designs for the entry into Antwerp of the Cardinal-Infante Ferdinand were executed in 1634. Paintings for the Torre de la Parada, Philip IV's hunting lodge near Madrid, were done in 1636–40. Rubens died May 30, 1640, and was buried in the family vault in the church of St. Jacques at Antwerp.

This young man with long curly hair is shown bust-length, turned toward the left but glancing toward the front, clad in steel armor with a red scarf over his left shoulder. The background is quickly laid in in a neutral tone.

Brockwell was the first critic to connect the Putnam picture with a painting called *The Deceased Young Duke of Mantua's Brother,* a portrait which had at one time belonged to Charles I of England (see references). Brockwell assumed that the Putnam painting, then in the collection of Leonard Gow, was one of the works which Abraham van der Doort listed for Charles I as number eleven, on show in the little room between the Breakfast Chamber and the Long Gallery at Whitehall (see Bodleian Library MS. Ashmole, 1514, fol. 52, ed. O. Millar, Walpole Society, 37 [1958–60]: Glasgow, 1960).

The young duke in question was Francesco IV, the eldest son of Vincenzo I, Gonzaga, Duke of Mantua, and Eleonora de' Medici. In an article in the *Burlington Magazine,* Jaffé has now established that a portrait hanging in the Billiard Room at Saltram House, and not the Putnam portrait, should be identified as *The Deceased Young Duke of Mantua's Brother,* the painting mentioned in the King's inventory (see references). Since Francesco IV died in 1612, Rubens presumably would have painted his portrait in 1608.

Because of its strength and fluidity, the San Diego picture belongs stylistically to the mid-twenties, the same period as the Marie de' Medici in the Prado. Thus, the true identity of the handsome, lively young captain is once again an unsolved problem. Perhaps we come nearer a solution with Professor Jaffé's further suggestion that "either it, or Mrs. Louis Hyde's picture [Goris and Held, no. 22, see references], could have been 'a man in armour with a red scarf'; No. 129 in the Inventory of Rubens' goods in 1640."

Two copies of the Putnam painting exist: one, a small panel from the Clowes collection (see Indianapolis, John Herron Art Musem, *Paintings from the Collection of George Henry Alexander Clowes,* 1959, no. 51); the other, a chalk drawing formerly in the Wellesley collection (London, Burchard, Wildenstein & Co., exhibition catalogue, no. 30, see references).

A. M. and E. M.

28 Jacob Isaacksz van Ruisdael
 View of Haarlem

oil on canvas
23½ x 30⅝ in. (59.7 x 77.8 cm.)
signed lower right: J Ruysdael (with the J. R.
in monogram)

Ruisdael was born in Haarlem in 1629, the
son of the painter and picture dealer Isaac.
He was apprenticed to his uncle Salomon
van Ruisdael. Cornelis Vroom was an
influence in his early years. Between 1650
and 1655 Ruisdael traveled in the East
Netherlands and to Bentheim and Cleves.
In the following year he settled in Amster-
dam. In 1676 he graduated as a doctor
of medicine at Caen and later practiced at
Amsterdam. Ruisdael died in 1682, prob-
ably in Amsterdam, but he is buried in
Haarlem.

This magnificent panoramic view of Haar-
lem must have been much in demand, for
Ruisdael repeated it several times, viewing
it from slightly different angles. In the
View of Haarlem, Mauritshuis, The Hague,
the bleaching fields appear to the right and
the view of Haarlem is more topographi-
cal (Hofstede de Groot, no. 65; Rosenberg,
no. 48). In the *Bleaching Fields,* Ruzicka
collection, Kunsthaus, Zurich, the artist
has moved his position to the left and in-
cluded a pool just to the left of the fields
(Hofstede de Groot, no. 59; Rosenberg,
no. 64). Another variant of the theme is in
the Rijksmuseum, Amsterdam. These pic-
tures were apparently painted about 1670.

 This stately, carefully constructed view
of Haarlem represents the epitome of
Dutch landscape art. Although painted in
the artist's full maturity, it shows still
some indebtedness to such views of Haar-
lem as were drawn by Goltzius and
perhaps even Rembrandt's etched *View of
Amsterdam.* What is more significant is the
fact that Ruisdael, from a high ground,
selected what he considered most impor-
tant for his composition: not the sky
seeking the sea, not the church against a
long, luminous sky, not the sun-drenched
bleaching fields, but an essence of a scene.
Ruisdael was a complex and subtle man.
However, Rosenberg (see references) and
Goethe have written very perceptively of
his affirmation and joy in nature.
 A. M. and E. M.

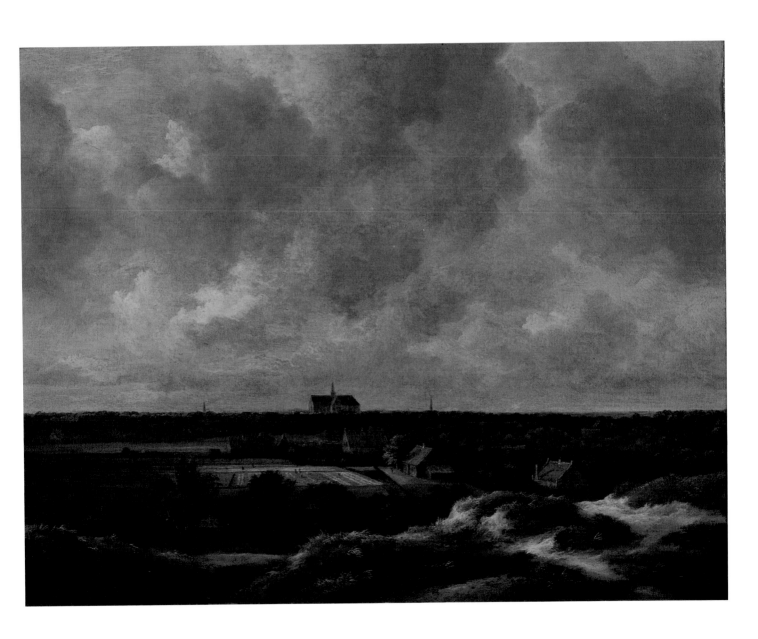

oil on panel
27³⁄₈ x 47 in. (69.5 x 119.2 cm.)

Savoldo was born in Brescia c. 1480. In 1508 he matriculated in the Guild at Florence. Thereafter, he worked in Venice, with trips to Treviso in 1512 and to Milan about 1530. Savoldo is last mentioned by Pietro Aretino in a letter dated 1548.

St. Anthony Abbot, clad in a robe with a long flowing *cappucchino,* his hands clasped in prayer, turns his head in consternation to gaze to the right upon a fantastic scene: in the right foreground, strange hybrid creatures cavort around a circular ruin; through a pierced area of rock in the middle foreground an unearthly light illuminates a man-of-war. A slimy gray-brown ooze ends on a distant shore where a mysterious town is on fire. (In his fourth century *Life of St. Anthony,* the Egyptian hermit St. Athanasius speaks of a ruined castle and burning church. They became traditional in art as attributes of St. Anthony Abbot.) The left half of the painting is bathed in serene light. In the left middle distance is a peaceful monastery and, in the far distance, alpine peaks.

The painting was published first by Antonio Boschetto in 1963 (see references). He dated it c. 1515–20, shortly after *The Prophet Elia,* National Gallery of Art, Washington, D.C., Samuel H. Kress collection. Creighton Gilbert suggested a date of 1535–38 (see references). Another treatment of the same subject, now in Moscow, was described in 1956 in an article by Guiseppe Fiocco ("The Flemish Influence in the Art of Gerolamo Savoldo," *Connoisseur,* 138 [December 1956]: pp. 166, 167, ill.).

The San Diego picture could have been painted only in Northern Italy during the High Renaissance. The head of the Saint bears some resemblance to Titian drawings of elderly men. As if to reinforce this illusion, the monastery to the left is not unlike Titian's house; the distant mountains could be those above Cadore. The rocks in the center are considered by some authorities to be directly related to rocks drawn by Leonardo, by others to Italian engraved copies of Durer's *St. John Chrysostom.*

Paolo Pino, one of Savoldo's only known direct pupils, called his master "an unusual man in our art and an excellent imitator." (*Dialogo di Pittura* [1548], eds. Rodolfo and Anna Pallucchini, Venice, 1946). Pino's two points can be expanded to say that Savoldo was indeed a very unusual painter in his day, perhaps not as well-known as he should have been. His eclecticism is made palatable in such early work as this through a personal color scheme: the use of rich plum, blue-gray, grayish white, and dark browns blending into fiery red and coppery yellow.

A. M. and E. M.

The derivation of the infernal scene on the right, from which St. Anthony is fleeing, from the work of Hieronymus Bosch seems certain, but the precise channels through which the influence reached Savoldo cannot be defined. The description in the notebook of Marcantonio Michiel of the collection of Cardinal Grimani in Venice in 1521—at a time when Savoldo was living there—includes three pictures by Bosch. The one described as a "canvas of hell with monsters" was presumably one of the sources on which Savoldo drew for the creatures in the right-hand half of the Putnam picture, but the description is not detailed enough to enable Bosch's picture to be visualized. Moreover, there is no evidence of how long it had been in Venice before 1521. There are in fact pictures of this subject by Bosch in the Doge's Palace in Venice at the present time, but they do not include all the Bosch-like creatures in the Putnam picture. In any case, it is not certain if any of them is identical with the Grimani picture described in 1521, as their history cannot be traced back uninterruptedly.

C. G.

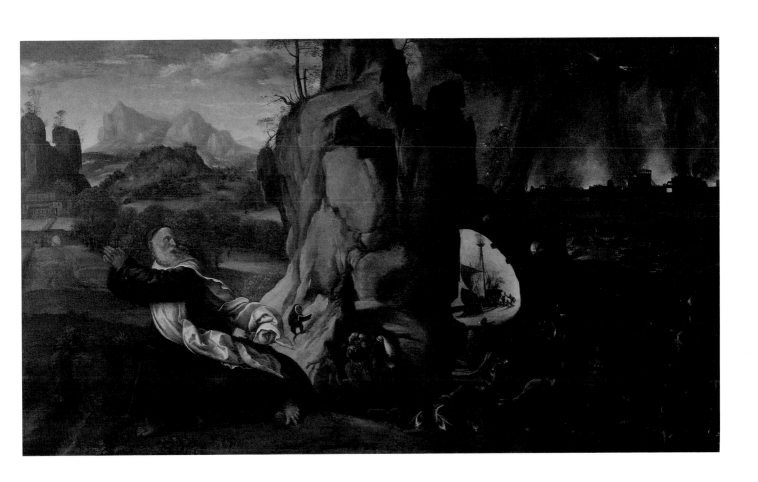

oil on panel
33⅞ x 26⅝ in. (85.9 x 67.6 cm.)
signed and dated on a cartellino *at upper left:*
1530 / Bartolo / mei / veniti / ·f·

The date of his birth is not known. He is
first identified in 1501. A native of Venice,
as his name implies, where he may have
been a pupil of Giovanni Bellini, he also
worked at Cremona and Turin and perhaps
at Ferrara as well. Most of his work
consists of portraits of elaborately dressed
people. Veneto died in Turin in 1531.

The sitter is shown at half-length, standing
in front of a dark red curtain to which the
cartellino is attached. A white underdress,
with black ornamentation, shows through
the slashes in the sleeves of her green satin
overdress and at the cuffs. A blue belt is
tied in a knot in front. An orange fichu
with red horizontal stripes and ornamenta-
tion covers the sitter's shoulders. She
wears a long necklace of dark blue stones
and, on the back of her head, a headdress
like a wig, ornamented with blue and gold
ribbon. She has removed her left glove
and holds it in her left hand. The fashion-
able costume and headdress is similar to
that in Lotto's *Portrait of a Lady as Lucrezia,*
National Gallery, London (no. 4256).

The first letter of each line of the inscrip-
tion on the *cartellino* is painted as though
in shadow. The Latin of this inscription
appears to be incorrect, being a combi-
nation of alternatives. It should be either
"Bartolomeus Venetus f" (for "fecit"—
"Bartolomeus Venetus made me") or
"Bartolomei Veneti opus" ("the work
of Bartolomeus Venetus").

A comparable portrait by Bartolomeo
Veneto is in the National Gallery of
Canada at Ottawa (no. 16909). There is no
reliable clue to the identity of the sitter
of the San Diego picture.

 C. G.

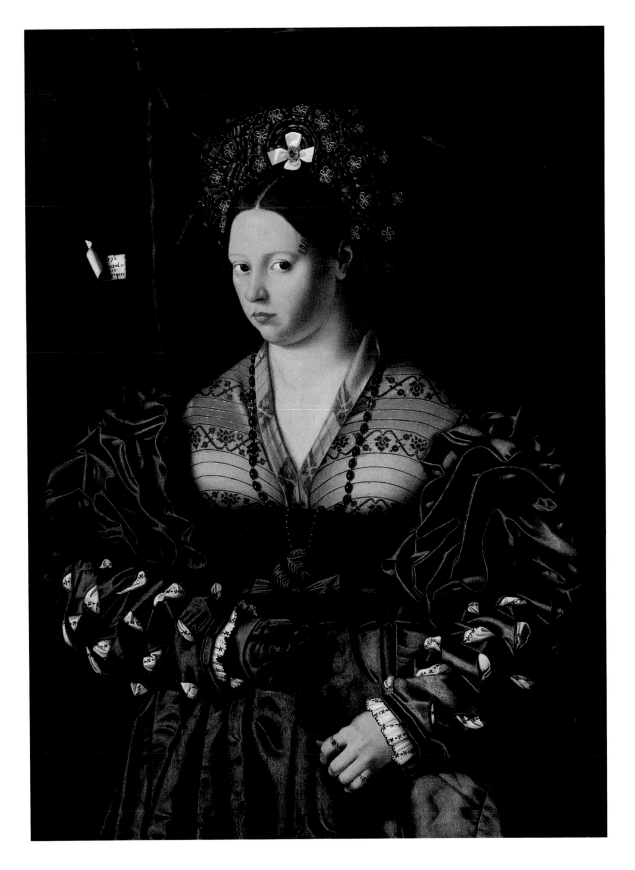

oil on canvas
44⅞ x 64⅝ in. (114.0 x 164.1 cm.)
signed and dated on the end of the box, below
the lighthouse, on which a turbaned figure is
seated smoking: Joseph Vernet / f. Romae 1749

Vernet was born at Avignon in 1714. He went to Rome in 1734, where he married an Englishwoman, Virginia Parker, leading to patronage from rich young English nobles and others who were doing the Grand Tour. Vernet returned to Paris in 1753, where he was commissioned by Louis XV to paint a series of French seaports. He died in Paris in 1789. His father, Antoine, and his son, Carle, were also painters; and the latter's son, Horace Vernet, was, in his day, the most famous of all.

On the left is a large warship with one gun firing, presumably as a salute. Many other ships can be seen in the distance. The nearest ship flies no less than three Dutch flags (horizontal stripes, red at the top, white in the center, blue at the base) and a very long pennant of the same colors which has blown over, so that the order of the colors appears reversed, with blue at the top and red at the base. Four other ships— two on each side of the big one—fly the same flag.

The lighthouse which is shown on the right and which recurs, with minor architectural variations, in other pictures by Vernet and other painters, is evidently the ancient lighthouse of Naples, "La Lanterna," which existed until the nineteenth century. Nevertheless the inclusion, behind the lighthouse, of mountains which are not in the vicinity of Naples, and, on the extreme right, of the Arch of Constantine, which is in Rome, and of the word "Romae" after the artist's signature to show that he was resident in Rome at the time he painted the picture, suggest that it was not intended as a specific view either of Naples or of anywhere else, but rather that it was intended to be seen as an ideal Mediterranean seaport, conceived somewhat in the manner of Claude Lorrain. Vernet is known to have had a special admiration for Claude, who had himself included the Arch of Constantine as a *capriccio* in a landscape now belonging to the Duke of Westminster (*Liber Veritatis,* no. 115). The inclusion in the present picture of turbaned orientals, seen on the

quay below the lighthouse, also occurs from time to time in Claude's seaports as a picturesque detail.

The Timken painting has been identified (for instance, in the Claude Joseph Vernet exhibition, Musée de la Marine, Paris, see references) as one of a pair which figured as lot twenty-two in the sale catalogue of pictures belonging to the Comte de Merle (see references). On the strength of entries in Vernet's notebook (Lagrange, p. 378, see references) which record his accompanying the Comte de Merle on hunting expeditions in November and December of 1748, the present picture, which is dated 1749, has been thought to have been commissioned by de Merle at that time.

Although the details of the picture as given in the sale catalogue do not entirely tally with the present picture, it is possible that this is due to haste and carelessness, since the description of a Vernet in the possession of the Comte de Merle in 1783 (Joullain, see references) corresponds better with the present picture. The Comte de Merle was certainly an admirer of Vernet's art, as he commissioned two pictures from him in 1772 (Lagrange, p. 350, see references). But if he owned the present picture, he is likely to have acquired it from a previous owner rather than commissioning it from the painter. This assumption stems from the inclusion, and the prominence, of the Dutch flags. The fact that the figure in the center of the picture, shown being greeted by his family, has just disembarked from one of a fleet of Dutch warships and that he wears a hat trimmed

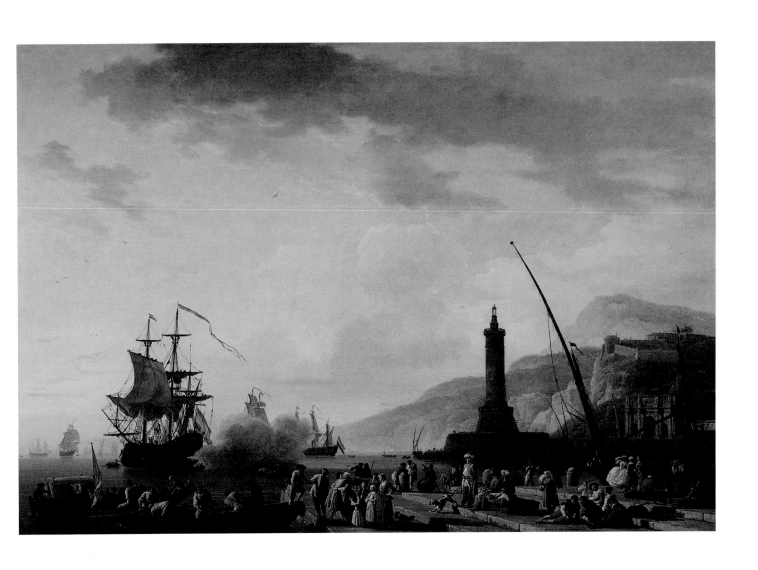

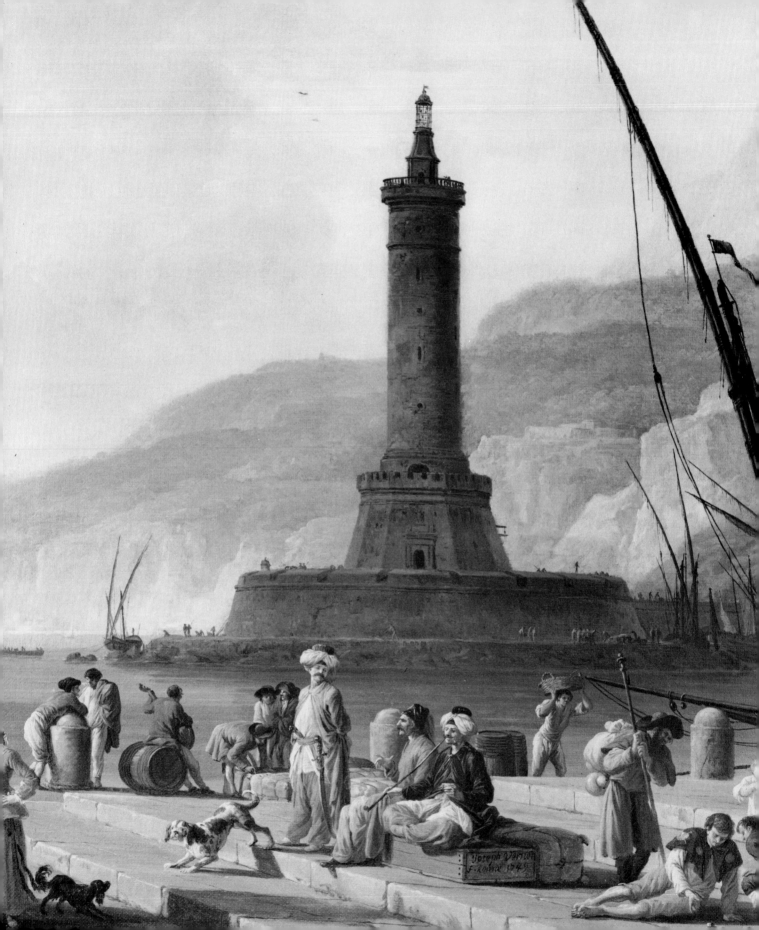

with gold, suggests that he is a Dutch naval officer. Mr. E. H. H. Archibald, of the National Maritime Museum, Greenwich, writes that from the second quarter of the seventeenth century the Dutch navy kept a permanent presence in the Mediterranean to protect their merchantmen from the Barbary pirates. He adds that the blue and white stripes, seen in the flag of the barge on the left of the picture, were Barbary colors. A further communication, from Mr. R. M. Vorstmann of the Rijksmuseum "Nederlands Scheepvaart Museum," Amsterdam, states that after the conclusion of the Treaty of Aken on October 18, 1748, two Dutch squadrons sailed for the Mediterranean. One squadron was under the command of Rear Admiral H. Linjslager who arrived at Malta towards the end of November 1748, and then set sail for Constantinople, where he arrived on September 24. He was back in Malta in May 1749. The other squadron, commanded by Rear Admiral Alexander Frensel, arrived at Algiers on April 5, 1749.

In view of the closeness between these dates and that of the Timken picture, it does seem a possibility that the painting may have been commissioned to commemorate, in some way, one of these expeditions, and in any case it establishes the probability that it was ordered by a Dutchman. Vernet's notebook for 1766 notes that he painted two pictures in that year for "M. Oudermeulen" of Amsterdam, for whom, at an unspecified previous date, he had already painted a sunset with a lighthouse, a colonnade, and a Dutch warship in the background (Lagrange, p. 46). The specification of a colonnade, rather than the Arch of Constantine, and of only one Dutch warship militates against identification with the present picture. But at least these notations constitute confirmation that Vernet had Dutch clients and was prepared on occasion to depict Dutch warships.

C. G.

32 Paolo Caliari, called Veronese
Madonna and Child with Saint Elizabeth, the Infant Saint John, and Saint Justina

oil on canvas
40⅞ x 62¼ in. (103.7 x 157.9 cm.)

Born in Verona c. 1528, Veronese was first a pupil of Antonio Badile of Verona. Later he studied the work of Giulio Romano at Mantua. Veronese was influenced by the prints of Parmigianino and the drawings of Primaticcio. In 1551 he worked at Villa Soranzo near Castelfranco. In 1552 he went to Venice. Veronese was one of seven artists who decorated Sansovino's "Libreria" in 1556. His first trip to Rome was made in 1560. He worked at the Villa Barbaro, Maser, and painted the ceilings of the Sala del Collegio, Doge's Palace, Venice, in 1575–77. Veronese died in Venice in 1588.

To the right of center the Madonna is seated against a ruined wall holding the Child in her lap. At the right kneels St. Justina, dressed in a robe of luminous colors, her head in profile, her hair elaborately dressed with pearls. The infant St. John embraces the foot of the Christ Child. At the left, St. Elizabeth is seated at a table. Branches of a tree are silhouetted against the sky with light clouds to the left.

The picture, which shows the influence of Titian, was probably painted about 1555–60 in Venice. St. Justina, daughter of King Vitiliano and Queen Perpedigna of Padua, was baptized by St. Prosdocime, the first bishop of Padua. Her legend is to be found in *Legendario delle vite dei santi* (Venice, Varischi, 1594).

St. Justina, a patroness of Padua and Venice, was greatly revered in both cities. The Paduans dedicated a magnificent church in her honor in the sixteenth century; her body was said to be buried behind the high altar. In Venice a church, a square, and a bridge were named for her. The church built by the Morosini family had been twice rebuilt by 1594. In the seventeenth century a façade was added by Longhena with sculpture by Clemente Moli representing members of the Soranzo family, descendants of the same family for whom Veronese had worked in his youth in Castelfranco (architectural information from Professor John McAndrew, letter, Autumn 1968). The church was closed in 1810 on orders from Napoleon's government. It had already suffered great damage when the ceiling fell in 1774.

Veronese painted two *Martyrdoms of St. Justina,* one now in the Uffizi, Florence (no. 589), the other in her church at Padua. He may have painted the San Diego picture for her church in Venice.
A. M. and E. M.

That the canvas has been reduced slightly at top and bottom can be seen by comparison with an engraving after the painting by Giovanni Vendramini (Ticozzi, see references).
C. G.

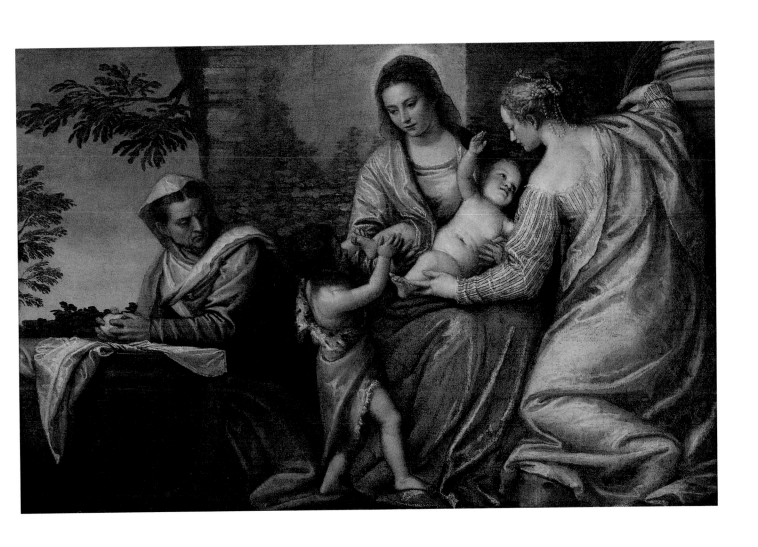

33 Emanuel de Witte
Interior of the Nieuwe Kerk, Amsterdam

oil on canvas
34½ x 40½ in. (87.6 x 102.9 cm.)
signed and dated lower right, in perspective, as
though carved on the floor of the church: E DE
Witte / INV A° 1657

Born at Alkmaar in 1615, de Witte lived in Delft from about 1641 to about 1651, when he moved to Amsterdam. He was originally a figure painter. Only after about 1650 does he seem to have specialized in church interiors, for which he is best known. He died in 1691 or 1692; apparently he committed suicide.

The church is seen from a point off center in the crossing of the transepts with the nave and choir, looking towards the west end. In the middle distance, on the left of the picture, a grave is being dug, some bones which had presumably been interred there at an earlier date being thrown out in the process. The sounding board, or tester, above the pulpit on the right of the picture (see below) seems at an earlier stage to have extended farther towards the left.

Work began on the construction of the Nieuwe Kerk (New Church) at Amsterdam around the year 1400. There were serious fires in the city in 1421 and 1452, and though their effect on the church is not recorded, it is established that the greater portion of the existing pillars and walls dates from after 1452. A further fire, in 1645, only twelve years before the date of the present picture, gutted the interior. Restoration seems to have been started immediately afterwards, and was more or less complete, structurally, within three years; but the pulpit, shown in the present picture, was not finished before 1664. It is by Albert Janszoon Vinckenbrinck. The great organ, also shown, likewise dates from after the fire of 1645. Its case was designed by the well-known architect, Jacob van Campen.

The coat of arms on the monument attached to the pillar on the left was identified by Professor I. G. van Gelder (in a private communication) as that of the Coymans family. Professor van Gelder found that two Coymans brothers, Balthasar and Joan, both died in the year 1657, the year in which the Timken picture was painted. The two brothers married sisters, Maria and Sophia Trip. They were a family of armaments manufacturers. Portraits of members of the Trip family were painted by many of the leading Dutch painters of the day, including Rembrandt. As Joan Coymans died at Velsen, and his brother Balthasar in Amsterdam, the picture more likely commemorates the latter, whose grave may be that which is being dug. Professor van Gelder also suggests that the lady on the right was Balthasar Coymans' widow. But she does not give the impression of being a portrait of anyone in particular, and her orange skirt would not be suitable as mourning. The Coymans monument is not now (1981) in the position in the church in which de Witte depicts it. Inquiries made at the church reveal that this monument is thought to have been dismantled before 1900 and has since disappeared. As de Witte is known to have taken topographical liberties on occasion, it is not certain if it was ever in the position in which it is shown.

C. G.

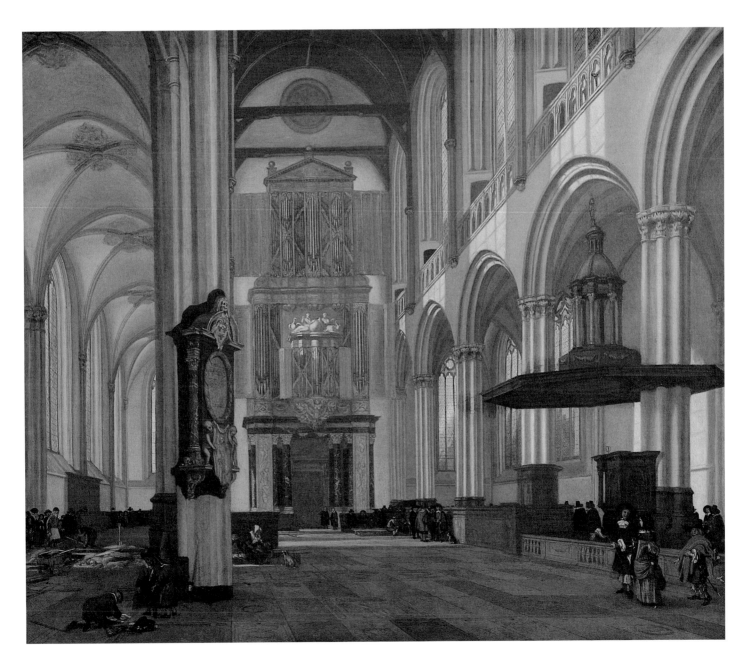

American
Works of Art

Introduction

The interest of the Putnam sisters was in Old Master paintings, and no American paintings were described in the first edition of the Timken Art Gallery's catalogue. However, the beginnings of the American art collection do precede the inauguration of the Gallery in October 1965. The first acquisition had been the fine Homer watercolor, *The Busy Bee,* in March 1964, and the second, the outstanding still life by Martin Johnson Heade, *The Magnolia Flower.* Within a year of the inauguration a superb Bierstadt and a major West joined the collection. This new direction in collecting derived from the foresight of the Putnam Foundation's first president, Walter Ames, who recognized the artistic value of the American school, then just beginning its rediscovery. Despite the lack of a critical consensus during those early years, his fine eye for quality selected works that have stood up as truly outstanding. Other works continued to be acquired, and early in 1972 came the centerpiece of the American collection, a work as important to its national school as any in the Putnam Foundation collection, the famous *Cranberry Harvest* of Eastman Johnson. Mr. Ames's last addition to the American collection was the striking *Halt, Dismount!* by Frederic Remington. By holding to the ideals of quality established for the European paintings, he had built the nucleus of an American collection of national note. The display of American paintings at the Timken Art Gallery began with the opening of the American room in December 1968. Since the Gallery's own collection of American paintings was still small at that point, the installation was filled out until 1975 by loans. Today, however, the American collection stands quite on its own, offering a compact survey of a range of styles and themes in the development of American art.

The cornerstone of the collection is *Fidelia and Speranza,* painted in the year of the Declaration of Independence by the man who, among his contemporaries and throughout the following century, was considered the dean of American art, Benjamin West. His talent had taken him from work as a portrait painter in Philadelphia to an honored rank in London as history painter to the king and later president of the Royal Academy. The Neoclassical style he brought to England was to prove a major turning point in Western European art. The Timken painting epitomizes the decorum and grace of this stately style, while also illustrating, within the collection, the type of highly idealized literary or historical painting from which American art evolved. Remington's *Halt, Dismount!* was painted

125 years after *Fidelia and Speranza,* when the fledgling nation of 1776 had become a world power. If we compare the collection's earliest work, the West, with the painting with which it closes, the Remington, we can see in a glance the profound changes the nineteenth century had brought to expectations for art. Instead of West's timeless moral sentiment, Remington presents a moment's inconsequential action; instead of muted colors and Old Master *chiaroscuro,* he gives us bright hues and the dazzling light of day; instead of graceful poses based on antiquity and the classic painters, we are shown the chaotic awkwardness and momentary distortions of abrupt action. West had sought to uplift the public with noble sentiments and perfection of form; Remington's generation tried to portray the present with greater vividness and immediacy than photography.

Although the overall trend through the course of the nineteenth century was clearly toward this realism, a love of the ideal and the poetical continued as a major strain that in the end inspired many of the works of greatest beauty and most enduring value. The Timken collection nicely balances these aspects of American art while sampling several of its major forms: landscape, still life, and genre painting. For at least half of the nineteenth century, from roughly 1825 to about 1875, landscape was the most significant art form and chief glory of the American school. The technical accomplishment and grand ambition of this aspect of American painting is seen in the Gallery's choice Bierstadt which, within its relatively modest format, grandly conveys the explorer's wonder at the majesty of the Far West. Its high finish and sense of fine detail contrast with the broader handling and conception of George Inness's *Ariccia* of 1874. The pastoral serenity of Inness's painting derives from the example of the great classic landscape painters, enhanced by a rich color and a gentle lyricism that made him the greatest of his school. Instead of Bierstadt's impressive spectacle, Inness presents a more delicate, more intimate experience of nature. The Gallery's still life by Heade curiously contains both strains of realism and poetry in one, its meticulous detail and tight brushwork supporting an image of great suggestion and evocative power. Among the collection's genre paintings, one admires the brisk realism obtained through the close observation of a characteristic expression or the accuracy of the position of a wrist in Homer's brightly sunlit *The Busy Bee,* while also enjoying the more elegaic vision of Eastman Johnson's late masterpiece, *The Cranberry Harvest,* festive but so full of autumn's gentle melancholy.

Although the Gallery's icon collection is more comprehensive, and individual Old Masters are brighter jewels in its crown, its American collection is fine and complete enough to represent a conspicuous area of strength. It is sufficiently varied in its subject and period, in style and mood, to offer a compact but revealing survey of its field. Its outstanding quality allows it to blend easily with the Gallery's choice Old Masters. The American collection was an inspired departure that has enabled the Putnam Foundation to more fully meet its high objectives.

Michael Quick

oil on canvas
34½ x 27⅛ in. (87.0 x 68.9 cm.)
signed and dated lower left: A Bierstadt / 1864
(the A.B. combined)

Albert Bierstadt was born on January 7, 1830, at Solingen, a town near Düsseldorf, West Germany. In early 1832 the family moved to New Bedford, Massachusetts. From 1853 to 1856 he studied at the art academy at Düsseldorf and then traveled in Germany and Italy before returning to New Bedford in 1857. He traveled through the West in 1859 and again in 1863, achieving immense success with the large, impressive paintings that resulted from the experience. Based in New York or nearby, he continued to make frequent, extended trips. Bierstadt died in New York on February 18, 1902.

The army surveys that prepared the way for the great westward expansion of the United States following the Mexican-American War of 1848 brought back to the Eastern cities accounts of unimagined spectacles of nature, which artists and photographers soon set out to capture for a fascinated public. Having already achieved fame as a painter of the Western American landscape, Bierstadt in April 1863 set out upon his second western trip, with the principal objective of visiting the valley of Yosemite, which he finally did reach during August of that year. The Timken painting places us at the second camp of the artists' party at the close of a day of sketching, as the six men gather for supper and a comparison of their day's studies, while their boy brings wood from among the grove of oaks and cypress and their man leads the pack animals down to pasture in the broad meadow bordering the Merced River. Across the valley thunders one of the wonders the group has come to see, the Yosemite Fall, or Cho-looke, to use its Indian name, the highest in the United States, with a cataract breaking its double fall.

Although the painting seems to record an actual evening of the party in the Yosemite, its size and degree of finish indicate that it was painted after the artist's return from the West in December of 1863. The *New York Evening Post* of June 9, 1864, recorded that he was at work on the painting then. Bierstadt's characteristic method would have been to base a finished painting such as this not only on detailed oil studies, such as that in the collection of Mr. Algernon H. Phillips, Jr., of Newark, New Jersey, but also on photographs or stereophotographs that he or members of the party took. Low clouds have been introduced to enhance the effect of vast distance, and an accident of light adds drama to the spectacle. Bierstadt has also composed the painting as an abrupt jump from a darkened and bulky foreground to a hazy and insubstantial distance. The ultimate objective is an impression of spectacular scale and natural majesty.

Fitz Hugh Ludlow, Bierstadt's companion on the trip, serialized an account of their travels in the *Atlantic Monthly* during 1864, the chapter on Yosemite appearing during June, when the Timken painting was on Bierstadt's easel. The inclusion of the artists' party in the foreground may have been at least partly in response to the topicality of the expedition, although it was also a favorite way of establishing the vast scale of the wonders Bierstadt portrayed. The painting, reproduced in a wood engraving, served as the perfect illustration to Ludlow's *The Heart of the Continent,* the book-length account of the journey published in 1870.

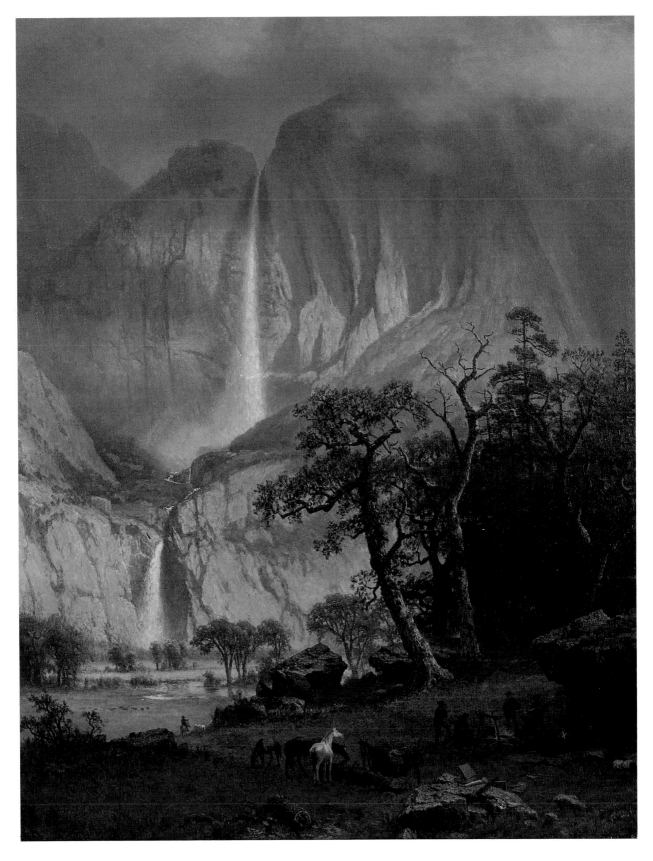

35 Thomas Birch
An American Ship in Distress

oil on canvas
36⅛ x 53¾ in. (89.1 x 136.4 cm.)
signed and dated lower right: Thos Birch /
1841 / Philadelphia

Thomas Birch was born in Warwickshire, England, in 1779, the son of the engraver and painter of portrait miniatures, William Birch. The family moved to the Philadelphia area in 1794. Thomas began his career as his father's assistant, established himself as a portraitist around 1800, and by 1811 was painting chiefly landscapes and marines. He made his reputation the following year with a series of paintings of naval engagements of the War of 1812. Death in 1851 closed his successful career as his country's first marine artist.

The violent storm is clearing that has torn off the mizzenmast and damaged the mainmast, sails, and rigging of the foreground ship that still rides a heavy sea. Either because the ship is already on the nearby rocks or because the captain is doubtful whether she has enough sail to avoid them, the crew begins to lower a lifeboat over the stern. A rescue party approaches the ship from the right and a sidewheeler and another vessel hurry to the relief of the ship from the left. A rugged coastline stretches across the background to a fort, a lighthouse, and a harbor in the distance.

The Timken painting is the more dramatic of a pair of paintings, the other (owned in Boston), a double portrait at sea of vessels identified as the ship *Monongahela* and the side-wheeler *Great Western*. Following the English tradition, Birch often painted such pairs in contrasting moods, one under fair skies, the other in a storm. Even ship portraits would sometimes show the same ship in a calm and a rough sea. The *Great Western* was one of the early steamships to sail between England and the United States, and the *Monongahela* was one of the packet ships of the Cope Line of Philadelphia that routinely sailed to Liverpool. The *Great Western* does not closely resemble the steamship in the San Diego painting, and the *Monongahela* is known to have had different stern carving than her Timken counterpart. But since the dismasted ship is of the same type and general appearance as several Cope ships, and since the coastline generally resembles the western coast of England, it is tempting to speculate

whether Birch may have painted a specific wreck or near-wreck of a ship of the Cope Line. The ship in the painting originally must have shown a legible name, but unfortunately the band beneath the stern windows where the ship's name and registry are usually to be found has been partially repainted, leaving only "of Philadelphia" in the original paint. Perhaps the distinctive taffrail carving of a bust of Washington between an American flag and an eagle bearing a flag-decorated shield may yet provide a clue to the identity of the ship, if a specific one was indeed portrayed. Birch was several times commissioned to paint the wreck of a particular ship, but he painted many more shipwrecks with no apparent specific reference.

Aside from the naval battles that made his reputation, Birch's shipwrecks are generally his most interesting and distinctive paintings. In the best of them he caught the drama and power of the French painter he seems to have admired, Joseph Vernet, known not only for his placid harbor scenes such as the Timken's *A Seaport at Sunset,* but also for his violently stormy coastal scenes and desperate shipwrecks that foreshadowed the taste of the Romantic period seen in the work of Thomas Cole and others of Birch's American contemporaries. The Timken painting is an unusually large and impressive one; its watery surfaces, the transparency and volume of the waves, the changing weather, and the accurate detail and persuasive plight of the ship show well the considerable talents of the founder of the American school of marine painting.

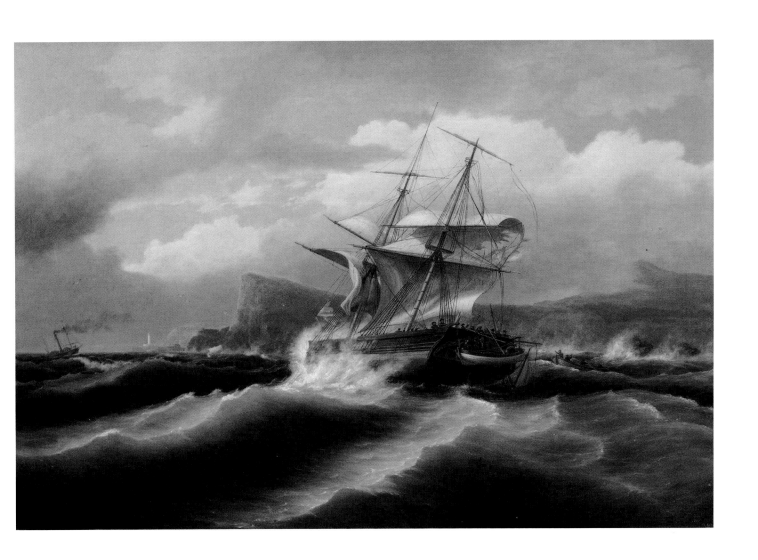

36 Martin Johnson Heade
The Magnolia Flower

oil on canvas
15⅛ x 24⅛ in. (38.4 x 61.3 cm.)
signed lower right: M. J. Heade; and on
reverse: M. J. Heade / 1888

Born in Lumberville, Pennsylvania, on August 11, 1819, Heade began his career as a portraitist but became known for his landscapes and his still lifes of Brazilian hummingbirds and orchids. He traveled widely, living primarily in New York. In 1883 he moved to St. Augustine, Florida, where he died on September 4, 1904.

A single, white magnolia flower, still attached to a cut twig and surrounded by a background of radiating light green leaves, rests, close to the edge of a table or shelf, upon a cloth of red velvet which hangs down from the right, passing behind the flower.

Heade's move to Florida in 1883, following his marriage late in life, was an important turning point in his artistic career as well, since he left behind some of the subjects closely associated with his name and explored several new ones. Of the flowers he considered, the giant magnolia became the chief still-life theme of his later life. Following his usual working method, Heade completed studies of the flower and based most of his finished paintings on these. The Timken painting appears to be related to one of the flowers in the *Study of Four Magnolia Blossoms* in the Historical Society of St. Augustine, Florida. A painting slightly smaller and somewhat less fully developed, but otherwise nearly identical to the Timken painting, has recently appeared on the market (Christie's, New York, March 18, 1983, no. 40).

The best of the fourteen known paintings of magnolias possess a fascination and power equaling anything Heade had produced in still life. In the magnolia, he had found another exotic tropical flower like the Brazilian orchids that had made his name. But while he painted the orchids growing in the jungle, all of the magnolias have been brought indoors to be enjoyed. The voluptuous flower has been given an added note of luxury by the generous

velvet cloth, a striking red in the Timken painting, rather than the blue or brown found in some others in the series. The flower in the Gallery's painting (and the similar Christie's painting) is unique within the series in opening to the right, as though shyly turning away from the viewer's normal left-to-right approach. Floating above the table in its aureole of waxy leaves, it yet unfolds its beauty, even allowing one welcoming leaf to touch the soft velvet. The strong contrast of red cloth and green leaves, and the rapid linear movement of the crisp edges of both leaves and petals lend an unmistakable presence to the large forms. The highly finished, realistic flower is wrapped in mystery and heavy with suggestive power.

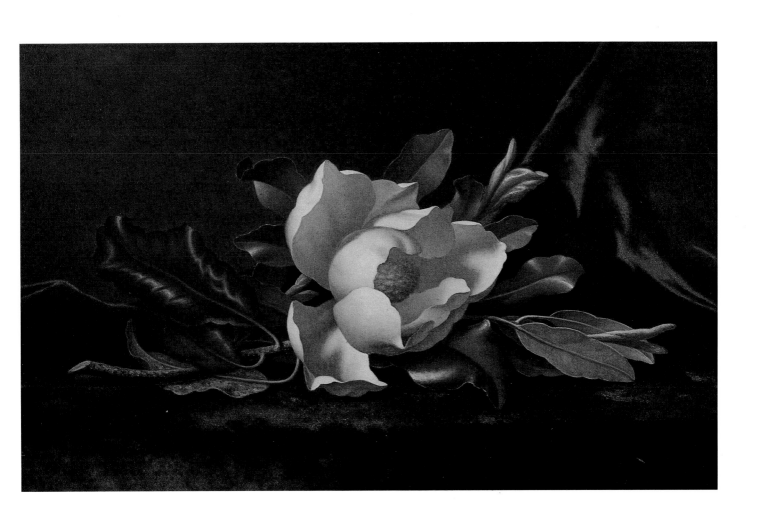

37 Winslow Homer
The Busy Bee

watercolor on paper
10 x 9⅜ in. (25.4 x 23.8 cm.)
signed and dated lower right: Homer 1875

Winslow Homer was born in Boston, Massachusetts, on February 24, 1836. He served an apprenticeship with a lithographer and briefly studied art after moving to New York in 1859. His primary career until 1875 was as the country's foremost illustrator. He first exhibited an oil painting at the National Academy of Design in 1860, emerging as a significant painter after the Civil War. Homer took up watercolor painting seriously in 1873. He was elected an associate member of the National Academy of Design in 1864 and a member in 1866. He spent 1867 in France and 1881–82 in England. Beginning in 1884 he lived at Prout's Neck, Maine, although he painted in the Adirondacks, the Caribbean, and other areas. He died on September 29, 1910.

A young black boy stands in the immediate foreground in a field of wildflowers and raises his straw hat to drive away a bee hovering before his eyes, an arm's length away. Meanwhile another bee has alighted on his right arm. Behind him are sheds for beehives and broad fields bordered by distant trees.

Winslow Homer is considered one of the very greatest of American artists not only for his command of technique and form, but even more for the clarity and strength of his independent vision. He was able to look freshly and to paint things as he saw them and felt their significance. Critics hailed this characteristic freedom from the conventional when he exhibited during the late 1870s a series of paintings and watercolors of Southern blacks, praising him for uncovering a promising new vein of subject matter for his fellow artists. *The Busy Bee* was among the approximately fifteen works resulting from Homer's visits to Petersburg, Virginia, probably in 1874 and 1875. Its young subject appears as a model in a pencil study, two paintings, and two other watercolors, including *Flower for the Teacher* in The High Museum of Art, Atlanta, Georgia. These are not simply transcriptions of daily life, but rather posed subjects of a slightly anecdotal nature not unlike his studies of the children of rural New England during these years. The boy's predicament in the Timken watercolor was understood by Homer's contemporaries to be amusing, although one recognizes in it a sympathetic humor quite unlike the racial stereotypes of the day. This derives, in part, from Homer's careful study of the boy's posture and physiognomy, of his expression, and of a characteristic gesture such as the hand held at the side. Their accuracy makes the subject an individual. In addition, Homer has drawn the figure unusually large in relation to the sheet, cut it at the knees, and thrown it into silhouette, so that it comes to the surface as a form of considerable force and monumentality.

Homer had become active as a watercolorist only two years earlier, yet one already sees in the San Diego painting a freedom and fluency that delights the modern eye. On a framework of pencil outlines, its forms are built up by overlapping washes, with just a few highlights of opaque white. Here again Homer was unconventional, since within the large and very popular exhibitions of the American Water Color Society, filled with highly finished Victorian watercolors betraying little evidence of the painter's brush, Homer's direct technique seemed outrageously crude. *The Busy Bee's* lack of detail in the glare of sunlight and its blocky foreground brushwork are nevertheless part of the sincerity and integrity that have enabled it to live beyond its period.

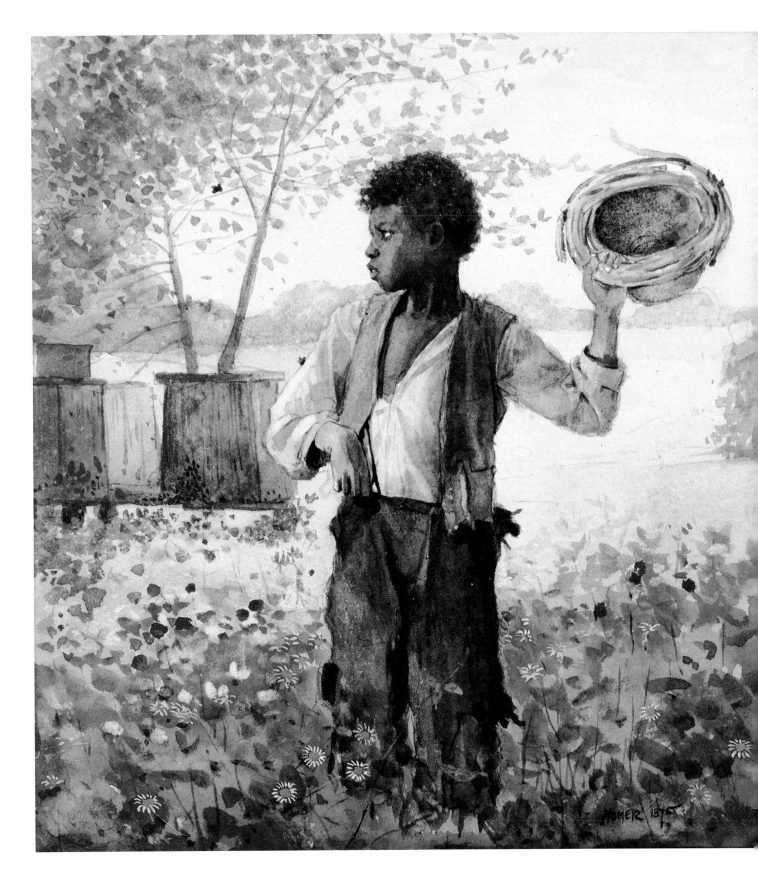

oil on canvas
26½ x 56⅞ in. (67.3 x 144.3 cm.)
signed and dated lower right: G. Inness 1874

George Inness was born on May 1, 1825, near Newburgh, New York, and was raised in Newark, New Jersey. He had a very limited training and briefly worked as an engraver before exhibiting his first landscape at the National Academy of Design in 1844. He traveled in Europe in 1850–52, again in 1854–55, and finally during 1870–75. He was elected an associate member of the National Academy of Design in 1853 and a member in 1868. Over the course of his fifty-year career as a painter, he worked and vacationed in several locations, but is primarily identified with the New York area. A retrospective exhibition in 1884 established his preeminence in his field, and he enjoyed increasing fame until his death on December 27, 1894.

The rosy-beige, tan, and white buildings of an Italian town crown a ridge stretching across the middle distance. A valley and answering ridge lie beyond, before a hazy distance. A stone bridge crosses the foreground. The time is very late afternoon, with a crescent moon in the sky on the left.

Inness's stay in Italy during the early 1870s was a time of ripening for his strong landscape vision and led to the classical style of his middle period. Although he visited other cities, he painted primarily in Rome and its environs, finding many of his subjects among the scenic lakes and deep valleys of the Alban Hills and the towns of Genzano, Castel Gandolfo, Ariccia, and Albano, an hour from Rome by train in those days. The region's familiarity to tourists made his paintings more readily salable back home, where they were handled by Inness's Boston agents, Williams and Everett, as the Timken painting was. Views from these hilltop towns also offered him panoramas of mist-filled valleys not unlike the motifs favored by the American landscapists of the Hudson River school and actually sought out in the same area by Sanford Gifford, for instance.

Although the town represented in the Timken painting is identified in the titles of several Inness landscapes as Albano, it is clearly the neighboring town of Ariccia with the drumless dome and apsidal towers of the church of Santa Maria dell' Assunzione built by Bernini in 1664, facing the Palazzo Chigi with its towers rising above the town. The view seems to be from the east-southeast, looking beyond

the Vale of Ariccia to the Roman Campagna lost in the hazy distance. The bluer band at the horizon on the left could be the Mediterranean. The towns and hilly countryside were connected by numerous bridges and viaducts which seem in other paintings to have interested Inness as he explored the spatial complexity of the area. The unusually wide Timken painting, related to an even more panoramic oil study (sold at Parke-Bernet Galleries, N.W., February 1, 1940, no. 27), uses the long bridge as the first of three parallel horizontal elements, continued in the actual horizon and the strata of thin clouds, and balanced by the upthrusting geometry of the town.

The best Innesses of these years go beyond mere scenery to offer a poetic sentiment of the most delicate kind. Color is a large part of it, the rich and varied greens of the foreground and middle distance, and the sky and distance entirely in pink and blue, but another part is the capturing of the characteristic light of a particular time of day. In the Timken painting it is that transitional moment at the end of the day as the warm light fades upon the land, a brief time of stillness and tender melancholy to which Inness was often to return in his later work.

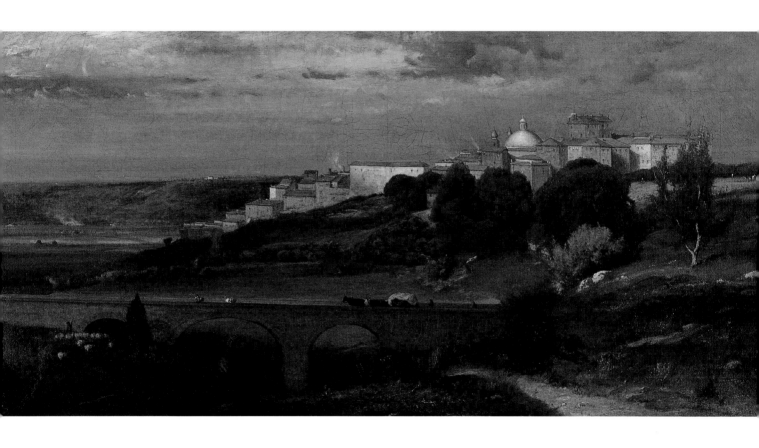

oil on canvas
27½ x 54⅝ in. (69.7 x 138.7 cm.)
signed and dated lower right: E. Johnson 1880

Jonathan Eastman Johnson was born in 1824 in Lovell, Maine. Around 1844 he began to achieve success as a portrait draughtsman, working in Washington, D.C., and elsewhere before sailing to Europe in 1849 to study at the academy in Düsseldorf. In the early 1850s he worked in The Hague as a portraitist. In 1855 he studied briefly in the studio of Thomas Couture in Paris before returning to the United States. Johnson had his first great success as a genre painter in 1859 and soon came to be recognized as one of the leading figures in that field. He was active primarily in New York but in 1871 bought property on Nantucket Island where he summered for the rest of his life. In the early 1880s he turned once more to portraiture, painting his last genre scene in 1887. He died in 1906.

The figures of men, women, and children are scattered across a broad field in the positions of gathering, carrying, and loading the products of the cranberry harvest. The ridge behind them slopes downward from the right toward a town and harbor.

During the late nineteenth century most national schools of painting, following the example of the French, produced numerous scenes of rural life and labor, often favoring crops identified with their own country. While in Fryeburg, Maine, Eastman Johnson had worked toward a never-realized major painting of a maple sugar harvest, and in Nantucket he painted a large cornhusking subject and finally the Timken cranberry harvest, the masterpiece of the later part of his long career as a genre painter. Although the subject is uniquely American, the painting reflects a sophisticated awareness of the French tradition in motifs such as the central standing figure, which recalls the resting gleaner of Jules Breton, and the paired stooping figures to the right of her, which reflect in their rhythmic poses the gleaners of Breton and Millet before him.

The Cranberry Harvest, together with the *Corn Husking at Nantucket* (Metropolitan Museum of Art, New York) of 1876, stand out among Johnson's usually intimate work for the impressive sweep of their open space. The roughly cross-shaped foreground group establishes the main diagonals that open up the space, the one on the left toward the horizon at the picture's edge, and the secondary, shorter one toward the wagon. The three children on the left and the bags of cranberries on the right extend these diagonals through the main foreground group into the lower corners of the canvas. The standing woman thus serves as the pivot of the composition. Corresponding standing figures rise from the large central group in the distance. (The bending woman in blue between the two large distant groups appears to be a later addition.) As one follows these unifying strands and their informal variations one encounters the range of characters that Johnson had brought before the American public during his long career. Most readily identifiable is Captain Charles Myrick, the elder, top-hatted man seated in the foreground to the left of center, who figures in several Nantucket paintings such as *The Reprimand* and *Embers.* A curious child, a motif also frequent in Johnson's work, looks up at the eccentric elder. Children were a favorite subject for the artist, ones like the inherently slightly comic group in the left corner or the responsible older brother on the far right who carries a baby apparently to the standing woman in the foreground who looks his way. Behind the gleaning pair one encounters a shy maiden and her young suitor, and throughout one discovers individuals of distinctive characterization. The full baskets and bags indicate a late hour, and a low sun rakes across the field and its figures, finding in each a strong accent in red, yellow, green, or blue amidst the gathering obscurity. These add a note of cheerfulness while establishing the independent individuality of all who

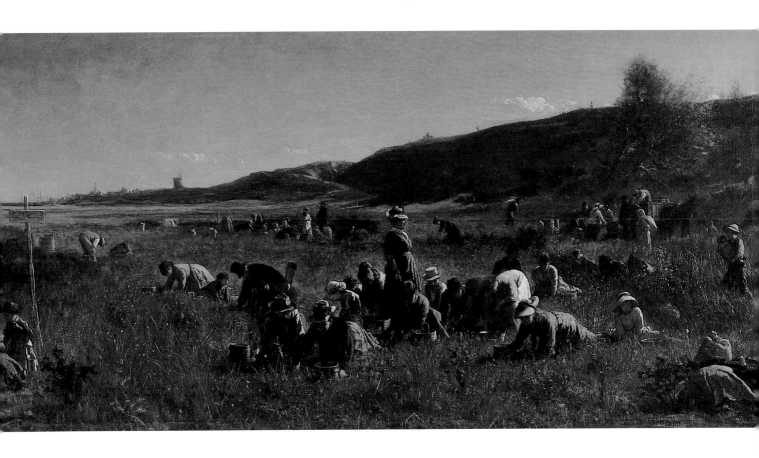

have momentarily been brought together by the urgency of the harvest. This is the happy, fulfilling side of rural life that one encounters in the harvests of Thomas Hardy. It is likewise tinged with a gentle nostalgia for a traditional country life that was giving way to progress and the city.

The rise of land that slopes behind the figures toward the town of Nantucket and its harbor (but without the windmill, a spot of local color Johnson moved here) is known as the North Cliff. Johnson's own house was near the location of the painting, in the immediate vicinity of the North Cliff, a spot that within ten years was full of summer houses and bathing facilities. One would think he must have often looked out his window at the harvesters and then taken the short walk to stroll among them, creating the numerous oil sketches that record their activities. These figures were then varied and tried in several groupings before the Timken painting

evolved, with only one known close compositional study, *Cranberry Pickers* (private collection, Whitney exhibition, no. 89, see references). A painting of what was for Johnson an epic scale and complexity, it is his final great statement in genre painting. This ambitious work, carried out in his broader late style, summarizes and crowns a long career, as well as an era in the nation's life and art.

Do not leave?

oil on canvas
30¼ x 51⅜ in. (76.8 x 130.3 cm.)
signed and dated lower right: Frederic
Remington / 1901

Frederic Remington was born on October 4, 1861, in Canton, New York. He received his artistic training while attending Yale College from 1878 to 1880. After attempts at ranching and business in the West, in 1885 he studied briefly at the Art Students League in New York and began a career as an illustrator, achieving great fame as a specialist of cavalry life in the West and later in cowboy and Indian themes. Having exhibited paintings since 1887, he was elected an associate member of the National Academy in 1891. In 1895 he executed his first sculpture. He died in 1906.

Perhaps the best description of the Timken painting are Remington's own words:
Being a cavalry column—suddenly fired on from opposite bluffs—the officer raising hand indicating 'Halt— + bugler blowing—white and indian scouts in center and all the troop horses twisting back on their bits. It gives good chance for action of rather unconventional form. Canvas about 50 inches long.
Remington jotted these lines under a pen sketch of the painting sent to Mr. Benjamin W. Arnold of Albany, New York, in a letter proposing a subject for the painting that Arnold had commissioned. (The letter and sketch and a subsequent letter to Arnold indicating it was already laid in on January 4, 1901, are all in the Putnam Foundation collection.) Remington was at the peak of his abilities at that time, and the painting, which remained in the Arnold family until acquired by the Putnam Foundation, is generally considered one of the artist's finest achievements.

Numerous elements went into making Remington the foremost artist of the Old West. His art stands at the end of the tradition of the French military painters such as Ernest Meissonier and Edouard Detaille whom Remington had admired at the beginning of his career. Like them, he had cultivated a detailed knowledge of military uniforms and procedures, but he went beyond even these acknowledged masters in his intimate understanding of the anatomy and movements of horses. In *Halt, Dismount!* the just reined-in mounts are caught, as in the click of a camera's shutter, in the awkward and distorting positions of a split second. With the whole column suddenly stopping, we see a dozen revealing momentary postures exploring the horses' reactions and possibilities of motion. Although Remington was known as a painter of action, few of his works are as abrupt in their violent movement; the Timken painting shares this quality rather with Remington's bronzes with their sense of frozen time. This additional quality of realism must have come at least partly from the advances in photography, now better able to capture momentary poses, although Remington denied having seen Eadweard Muybridge's studies of equine movement. It may also have developed from Remington's years as an illustrator who needed to hold in his mind and record a scene in motion, in order to bring it vividly to life on a page on which an actual news photograph might be reproduced, thanks to recent advances in printing processes. As an illustrator he was competing with the immediacy of photography. In fact, while there are numerous variations in detail between Remington's sketch and the final painting, by far the most significant one is a change of viewpoint that serves to enhance immediacy, placing the viewer closer and lower, so that he looks from a standing position at the advancing column that has stopped just in time. Another element contributing to a persuasive realism that Detaille had never achieved is the effect of strong light that Remington's blond palette, bright hues, bluish-cast shadows, and abrupt transitions from light to shadow create.

The subject of *Halt, Dismount!* is taken from the Indian wars that Remington's illustrations and reporting had been instrumental in bringing to wider attention in the East. The Battle of Wounded Knee had brought them to an end in late December 1890, just ten years before the San Diego painting was begun. So the setting and type of encounter in the painting were drawn from very recent history. *Halt, Dismount!* offers us, then, not the Old West wrapped in a soft nostalgia, but instead a dramatic incident from recent experience that Remington's veracity and unexpectedness bring vividly to life.

41 Theodore Robinson
An Apprentice Blacksmith

oil on canvas
60⅛ x 50 in. (89.1 x 136.4 cm.)
signed and dated lower right: TH Robinson
1888. Paris

Theodore Robinson was born in Irasburg, Vermont, on June 3, 1852. He entered the school of the National Academy of Design in 1874. In 1876 he left for Paris, where he entered the atelier of Carolus-Duran and studied with Jean-Léon Gérôme and Benjamin Constant at the Ecole des Beaux-Arts. In late 1879 he returned to New York but in 1884 again left for Paris. In 1888 he settled in Giverny, became acquainted with Claude Monet, and embraced the Impressionist style. In the following years he traveled back and forth between Giverny and New York. His work began to be recognized and his influence to grow before his early death on April 2, 1896.

A young boy in leather apron and sabots works at a forge at one end of a shop with materials and tools stacked about. Behind him, to the painting's left, stands an anvil.

The importance of the Timken painting for the artist is indicated by both the fact that he painted only one other painting of this grand size and that he exhibited it not only in the Salon of 1888 but also in the important survey of contemporary art at the Universal Exposition of 1889 at Paris. (The artist appears to have made a monochrome reduction of the painting, presumably for reproduction, but no other related works are known.)

From the historian's retrospective point of view it assumes additional significance because it stands at a fundamental turning point in his career. It would have been painted in Paris or the Barbizon of his earlier style, but after exhibition it was returned to him in Giverny, where, through a friendship with Claude Monet, he had come to be an Impressionist. Later he was to become one of the principal leaders of the movement in the United States.

The subject of tradesmen and the theme of people in an interior were both common in the French capital during the 1880s, and the San Diego painting follows others such as Robinson's *A Cobbler of Old Paris* of 1885. The artists' interest in figures in interiors coincides with a rage for the side-lighted paintings of Vermeer of Delft, and both probably from the development of photography of interiors. In the 1880s the baroque lighting of the previous decade was already old-fashioned, as artists sought to recreate the subtle gradations of cool natural light as it filtered across a deep interior. Robinson's rapid assimilation of Impressionism two years later was dramatic, but it was not begun without some considerable consciousness of both light and color. The gentle light effect in *An Apprentice Blacksmith* is far from the hot noontime glare that he was to capture in later works, but is altogether as consistent and carefully observed. This understated painting is also carried out in a rich chromaticism that makes the brown base of the anvil and floor and the gray front of the hearth out of a rainbow of harmonious tints. This approach is most readily observed in the stronger mixed colors of the boy's shirt. The shirt and the front of the hearth also draw attention to the overall freedom of the blocky brushstrokes. *An Apprentice Blacksmith* shows Robinson already working with all the essential elements of Impressionism in his approach, awaiting only the catalyst of Monet's friendship and example to bring them together in the brilliant new style. But for all that the Timken painting foreshadows and is not itself, it is every inch of its great size a Robinson. The delicacy, the evocation that were to make Robinson's poetic paintings so special among the works of the American Impressionists are already here for the careful observer.

42 Benjamin West
Fidelia and Speranza

oil on canvas
54¾ x 42⅝ in. (139.1 x 108.3 cm.)
signed and dated lower left: B. West / 1776

Benjamin West was born on October 10, 1738, in Springfield, Pennsylvania. At a very early age he received some instruction from the English portrait painter, William Williams, and by the age of eighteen had set up as a portraitist in Philadelphia. Impressed by his precocious gifts, patrons enabled him to travel to Italy in 1760. In 1763 he went to England where he was to spend the rest of his life. His Neoclassical style of history painting met with warm success, and in 1772 he was appointed Historical Painter to the King. He was one of the original members of the Royal Academy and in 1792 was elected its second president, a position he held, with a brief interruption, until his death in 1820. An artist of considerable influence internationally, he had welcomed a generation of American art students to his studio.

Fidelia, dressed in white, advances down a short flight of steps, carrying in her left hand a large brown book with gold clasps, and in her right a gold chalice from which a green snake emerges. Showing no fear of the creature, she looks downward and to the side. A faint radiance surrounds her head. Speranza is clad in a mauve dress partly covered by a blue-green mantle and bound with an orange sash. Sad in expression, she takes her sister's arm with her right hand and places her left hand upon her heart, while carrying a short brown anchor in the crook of her left arm. To the left in the painting a large arch opens upon a stormy landscape in which Una and the Red Cross Knight can be seen approaching.

West's subject closely follows stanzas twelve through fourteen of Book 1, Canto 10 of the *Faerie Queene* by Edmund Spenser, the Elizabethan poet. The passage occurs after Una (Truth) brings the sinning knight from the House of Pride and the Cave of Despaire to the House of Holiness, where his healing and conversion take place. The first to teach him are Fidelia (Faith) and Speranza (Hope), which Spenser described with their traditional attributes as cardinal virtues. Fidelia bears the book of the New Testament and the communion chalice of wine and water, in this case becoming the chalice of St. John, from which the poison was driven off in the form of a snake. Hope is likewise traditionally associated with an anchor and the color blue, and is shown looking heavenward. Spenser describes them as walking arm-in-arm because they are closely linked in Christian theology.

Besides *Fidelia and Speranza,* West painted two other subjects from the *Faerie Queene, Una and the Lion,* 1772 (Wadsworth Atheneum, Hartford, Connecticut), and *The Cave of Despaire,* 1773 (Yale Center for British Art, New Haven, Connecticut), responding to a widespread interest in subjects from the poem, particularly the more imaginative "Gothik" passages that the emerging Romantic movement characterized as sublime. West's *Cave of Despaire* was meant to be horrific in this sense, but *Una and the Lion* and *Fidelia and Speranza* are both in his "stately mode," the decorous Neoclassical style that West was influential in establishing in England and the Continent. A preparatory sketch for *Fidelia and Speranza* (sold at Sotheby's, London, March 22, 1979, lot 6) in fact, was cast in a fully neoclassical manner with columns and planar presentation. The final version of both paintings has been softened by elements of the new Romantic style—in *Fidelia and Speranza* specifically the stormy sky and the enveloping darkness—as well as by the diagonal recession. Still, West departs from Spenser in using classical dress, the proper costume for ideal subjects in the art theory of West's period. It is the very heavy drapery West used in the 1770s, and the figures display the graceful *contrapposto* and elegant gestures that he learned from his models in classical sculpture and the Old Masters he admired.

Smith has suggested that Fidelia may be a portrait of the Miss Hall whom he identifies as the model for West's Una (see references). She was born in Jamaica, mar-

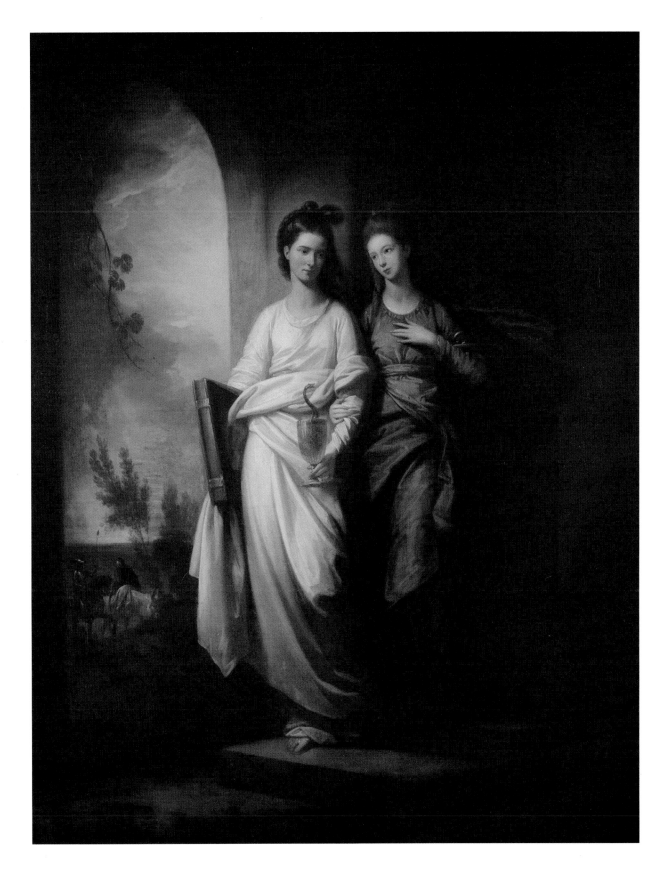

III

ried Richard James Lawrence of Jamaica, and died in London on January 20, 1815, aged 66. Allen Staley, in his forthcoming catalogue raisonné, intends to advance this theory of an allegorical portrait, presumably of sisters. Such portraits were common during the period, particularly in the work of Reynolds, and West is thought to have done several during the 1770s. Since West generally idealized the features of all his portrait subjects, identifications are often far from certain, but there is a resemblance between Fidelia and Una, which seems to be even more marked in the finished drawing West executed after the Timken painting in 1784 (Fogg Art Museum, Cambridge, Massachusetts). It is the kind of drawing with an emphasis on facial features that itself suggests a portrait use. The Timken painting was exhibited at the Royal Academy in 1777, and John Boydell on November 9, 1778, published a mezzotint after the painting by Valentine Green. However, the painting does not appear on the early lists of West's work, which is again characteristic of his portraits. It is interesting to note that John Singleton Copley's painting *The Red Cross Knight,* 1793 (National Gallery of Art, Washington, D.C.), contains portraits of his own daughters as Fidelia and Speranza.

References

1 Giovanni Antonio Boltraffio

Provenance: Marquis de Gallo; purchased in Paris in 1806 by the 7th Earl of Elgin; Earls of Elgin and Kincardine. Acquired by the Putnam Foundation, 1964.
Literature:
Waagen, G. F. *Galleries and Cabinets of Art in Great Britain* (also known as *Art Treasures in Great Britain*, vol. 4). London, 1857, p. 444.
Berenson, Bernhard. *North Italian Painters of the Renaissance.* New York, 1907, p. 172.
Teall, Gardner. "Giovanni Antonio Boltraffio." *International Studio,* 85, no. 353 (October 1926): p. 25.
Suida, Wilhelm. *Leonardo und Sein Kreis.* Munich, 1929, p. 289, as Pseudo-Boltraffio.
Mauceri, Enrico. "Dipinti di raccolte inglese alla mostra d'arte italiana a Londra." *Dedalo,* 10 (May 1930): pp. 755, 758, ill.
Royal Academy of Arts. *Italian Art: An Illustrated Souvenir of the Exhibition of Italian Art at Burlington House London.* London, 1930, no. 91, p. 54, ill.
Mongan, Agnes and Elizabeth. *European Paintings in the Timken Art Gallery.* San Diego, 1969, no. 6, pp. 28, 29, 109–10, ill.
Fredericksen, Burton and Zeri, Federico. *Census of Pre-Nineteenth Century Italian Paintings in North American Public Collections.* Cambridge, Massachusetts, 1972, pp. 30, 524, 632.
Exhibited:
Manchester. *Catalogue of Art Treasures of the United Kingdom.* 1857, no. 143 p. 23, as Leonardo da Vinci but with the notation: "the work, most probably, of Antonio Boltraffio [sic]."

London. Burlington Fine Arts Club. *Illustrated Catalogue of Pictures by Masters of the Milanese and Allied Schools of Lombardy.* May–July 1898, no. 47, pl. X, attributed to Leonardo da Vinci.
London. Royal Academy of Arts, Burlington House. *Exhibition of Italian Art, 1200–1900.* January 1–March 8, 1930, no. 320, p. 186.
London. Royal Academy of Arts, Diploma Gallery. *Leonardo da Vinci Quincentenary Exhibition.* 1952, no. 256, p. 70.

2 François Boucher

Provenance: The Earl of Rosebery, Mentmore Towers, England (sold Sotheby's, London, March 11, 1964, no. 53). Acquired by the Putnam Foundation, 1965.
Literature:
Mentmore. 2 vols. Edinburgh, 1884, 1: p. 126.
Mongan, Elizabeth. "Boucher's Lovers in a Park." *Art News,* 66, no. 4 (Summer 1967): pp. 50–51, 79–80, cover ill.
Mongan, Agnes and Elizabeth. *European Paintings in the Timken Art Gallery.* San Diego, 1969, no. 36, pp. 96, 97, 131, ill.
Ananoff, Alexandre with Wildenstein, M. Daniel. *François Boucher.* 2 vols. Lausanne, 1976, 2: no. 501, pp. 176, 177, fig. 1394.
Ananoff, Alexandre with Wildenstein, M. Daniel. *L'opera completa di Boucher.* Milan, 1980, no. 529, pp. 128, 129, ill.

3 Pieter Bruegel the Elder

Provenance: Fernand Stuyck del Bruyère, Antwerp. Acquired by the Putnam Foundation, 1957.

Literature:
Friedländer, Max J. "Neues von Pieter Bruegel." *Pantheon,* 7 (February 1931): p. 58.
Michel, Edouard. "A Propos de Bruegel le Vieux." *Gazette des Beaux-Arts,* 7 (February 1932): pp. 126–32, ill.
Cinq Siècles d'Art, Memorial de l'Exposition. Brussels, 1935, 1: p. LVIII.
De Tolnay, Charles. *Pierre Bruegel L'Ancien.* Brussels, 1935, pp. 75–76, fig. 143.
Orangerie des Tuileries. *L'Art flamand: De van Eyck à Bruegel.* Paris, 1935, p. 59.
Puyvelde, Léo van. *Pierre Bruegel l'Ancien à l'Exposition d'Art ancien de Bruxelles.* Brussels, 1935.
Glück, Gustav. *Pieter Brueghel, the Elder.* London, 1936, no. 6, p. 24, ill.
Friedländer, Max J. "Pieter Bruegel." *Die Altniederländische Malerei.* 14 vols. Berlin and Leiden, 1924–37, 14 (1937): p. 11, pl. IV.
Jedlicka, Gotthard. *Pieter Bruegel: Der Maler in Seiner Zeit.* Erlenbach, 1938, p. 513, pl. 3
Bruhns, Leo. *Das Bruegel Buch.* Vienna, 1941, no. 6, p. 14, ill.
Genaille, Robert. *Bruegel, l'Ancien.* Paris, 1953, p. 26.
De Tolnay, Charles. "An Unknown Early Panel by Pieter Bruegel the Elder." *Burlington Magazine,* 97 (August 1955): p. 239.
Grossman, F. *Bruegel: The Paintings.* London, 1955, pp. 18, 190, pl. 5.
Delevoy, Robert L. *Bruegel.* Geneva, 1959, p. 30, ill.
Denis, Valentin. *All the Paintings of Pieter Bruegel.* London, 1961, pp. 13, 26, 27, pl. 2.
Puyvelde, Léo van. *La Peinture flamande au Siècle de Bosch et Brueghel.* Paris, 1962, p. 81.

Bianconi, Piero. *The Complete Paintings of Bruegel.* Introduction by Robert Hughes. New York, 1967, no. 10, pp. 88, 90, ill.

Kay, Marguerite. *Bruegel.* London, 1969, pp. 16, 32, pl. 3.

Marijnissen, Roger H. *Bruegel.* Brussels, 1969, no. 5, pp. 38, 86–87, ill.

Mongan, Agnes and Elizabeth. *European Paintings in the Timken Art Gallery.* San Diego, 1969, no. 18, pp. 54, 55, 116–17, ill.

Stechow, Wolfgang. *Pieter Bruegel the Elder.* New York, [1969], pp. 19, 21, 52, pl. 1.

Roberts, Keith. *Bruegel.* London, 1971, p. 6.

Gibson, Walter S. *Bruegel.* New York, 1977, pp. 38, 42–43, 156, fig. 19.

Frati, Tiziana. *Bruegel: Every Painting.* New York, 1979, pp. 4, 13, fig. 3.

Exhibited:

Brussels. Exposition universelle et internationale. *Cinq Siècles d'Art.* May 24–October 13, 1935, 1: no. 133, p. 63.

Paris. Musée de l'Orangerie. *De van Eyck à Bruegel.* November–December 1935, no. 14, p. 15, ill.

Worcester, Massachusetts. Worcester Art Museum (and Philadelphia Museum of Art). *Exhibition of Flemish Painting.* Introduction to catalogue by Léo van Puyvelde. February 23–March 12, 1939, no. 94, p. 54, ill.

San Francisco. Golden Gate International Exposition. *Master Works of Five Centuries.* 1939, no. 3, ill.

Washington, D.C. National Gallery of Art. 1958–1965.

4 Guido Cagnacci

Acquired by the Putnam Foundation, 1971.

5 Luca Carlevarijs

Provenance: Arturo Grassi, New York, 1948; Sabatello, Rome; Bruschi, Florence; Paul Drey, New York. Acquired by the Putnam Foundation, 1979.

Literature:

Mauroner, Fabio. *Luca Carlevarijs.* Padua, 1945, p. 58.

Morassi, Antonio. "Una mostra de settecento veneziano a Detroit." *Arte veneta,* A. 7 (1953): p. 56.

Donzelli, Carlo. *I pittori veneti del settecento.* Florence, 1957, p. 54.

Udini. Loggia del Lionello (and Rome, Gabinetto Nazionale delle Stampe). *Incisioni e bozzetti del Carlevarijs.* Catalogue prepared by Aldo Rizzi. December 29, 1963–February 2, 1964, pl. XXXII.

Rizzi, Aldo. *Luca Carlevarijs.* Venice, 1967, p. 92, pl. 139.

Pallucchini, Rodolfo. "Miscellanea piazzettesca." *Arte veneta,* 22 (1968): pp. 106–30.

Exhibited:

Louisville, Kentucky. J. B. Speed Art Museum. *A Gallery of XVIII Century Venetian Paintings.* June 2–29, 1948, no. 4.

Detroit, Michigan. The Detroit Institute of Arts (and Indianapolis, John Herron Art Museum). *Venice 1700–1800.* September 30–November 2, 1952, no. 18. The painting is wrongly identified in the catalogue as one of four paintings commissioned from Carlevarijs by an English traveler, Christopher Crowe. These pictures were in fact still in the possession of Crowe's descendants at the time of the Detroit exhibition, but the mistake persisted (e.g. in Rizzi's book).

6 Paul Cézanne

Provenance: Horace O. Havemeyer, New York; Denver Art Museum, Denver; Dr. and Mrs. David M. Levy, New York; Adele R. Levy Fund, Inc. Assigned to the Putnam Foundation, 1962.

Literature:

H. O. Havemeyer Collection. *Catalogue of Paintings, Prints, Sculpture and Objects of Art.* Portland, Maine, 1931, p. 330.

Venturi, Lionello. *Cézanne: Son Art—Son Œuvre.* 2 vols. Paris, 1936, 1: no. 184, p. 107; 2: pl. 49.

Frankfurter, Alfred M. "Cézanne: Intimate Exhibition." *Art News,* 36, no. 26 (March 26, 1938): pp. 15–17, ill.

Venturi, Lionello. "The Denver Art Museum." *The Pacific Art Review,* 2, nos. 1 and 2 (Summer 1942): pp. 17, 18, fig. 3.

Mongan, Agnes and Elizabeth. *European Paintings in the Timken Art Gallery.* San Diego, 1969, no. 40, pp. 104, 105, ill.

Orienti, Sandra. *The Complete Paintings of Cézanne.* Introduction by Ian Dunlop. London, 1972, no. 225, p. 96, ill.

Exhibited:

New York. Durand-Ruel Galleries. 1938.

7 Philippe de Champaigne

Provenance: Studio of Philippe de Champaigne; inherited by his nephew Jean-Baptiste de Champaigne; Madame Gentil de Chavagnac; the Dukes of Ferrari de Galliera, near Dijon; inherited by a niece of the last Duke, Mademoiselle de la Renotière. Acquired by the Putnam Foundation, 1967.

Literature:

Vente Madame Gentil de Chavagnac. Galerie Labrun, Paris, June 20, 1854, pp. 37–39.

Stein, Henri. *Philippe de Champaigne et ses Relations avec Port-Royal.* Paris, 1891, p. 17, n. 13.

Vicomte de Groucy. "Les Peintres Philippe et Jean-Baptiste de Champaigne: Nouveaux Documents et Inventaires après Décès." *Nouvelles Archives de l'Art français, troisième Série (Revue de l'Art français ancien et moderne),* 1892; reprint ed., Paris, 1973, 8: nos. 13, 12, pp. 182, 196.

Mongan, Agnes and Elizabeth. *European Paintings in the Timken Art Gallery.* San Diego, 1969, no. 35, pp. 94, 95, 130–31, ill.

Dorival, Bernard. "Philippe de Champaigne: Chercheur d'Ames." *Connaissance des Arts,* no. 273 (November 1974): pp. 126–33, ill.

————. *Philippe de Champaigne, 1602–1674: La Vie, l'Œuvre, et le Catalogue Raisonné de l'Œuvre.* 2 vols. Paris, 1976, 1: no. 230, pp. 7, 99, 121, 122, 141, 178; 2: p. 128, ill.

8 Petrus Christus

Provenance: Villa Santa Canale, Bagheria, Sicily. According to family tradition the picture had been in Sicily since the early 1500s. Acquired by the Putnam Foundation, 1951.

Literature:

Venturi, Adolfo. *Storia dell'arte italiana.* Milan, 1915, vol. 7, part 4, p. 172, fig. 100 (before cleaning), as "Maestro della Metà del'400."

Marle, Raimond van. *The Development of the Italian Schools of Painting.* 19 vols. The Hague, 1934; reprint ed., New York, 1970, 15: p. 402.

Brian, Doris. "The Masters of Gothic Flanders." *Art News,* 41, no. 5 (April 15–30, 1942): pp. 14, 18, cover ill.

"Flemish Primitives." *Magazine of Art,* 35 (May 1942): pp. 168–69, ill.

Comstock, Helen. "The Connoisseur in America." *Connoisseur,* 110 (October 1942): p. 60, ill.

Van der Elst, Joseph. *The Last Flowering of the Middle Ages.* Garden City, New York, 1944, p. 70, pl. 47.

Friedländer, Max J. "The *Death of the Virgin* by Petrus Christus." *Burlington Magazine,* 88 (July 1946): pp. 159–63, ill. opposite p. 159, pl. IIc, d.

Bazin, Germain. "Petrus Christus et les Rapports entre l'Italie et la Flandre au Milieu du XVᵉ Siècle." *La Revue des Arts,* 2 (December 1952): pp. 194–209.

Panofsky, Erwin. *Early Netherlandish Painting.* 2 vols. Cambridge, Massachusetts, 1953, 1: no. 8, n. 5, p. 490.

Bruyn, Josua. *Van Eyck Problemen.* Utrecht, 1957, pp. 111, 113, 119, pl. 40.

Vegas, Liana Castelfranchi. "I rapporti italia-fiandra (II)." *Paragone,* no. 201 (November 1966): p. 48, pl. 33.

Faggin, Giorgio T. *Petrus Christus.* Milan, 1966, pp. 1, 4.

Mongan, Agnes and Elizabeth. *European Paintings in the Timken Art Gallery.* San Diego, 1969, no. 14, pp. 46, 47, 114–15, ill.

Gellman, Lola. "'Death of the Virgin' by Petrus Christus: An Altarpiece Reconstructed." *Burlington Magazine,* 112 (March 1970): pp. 146–48, ill.

————. "Petrus Christus." Ph.D. dissertation, The Johns Hopkins University, 1970, no. 20A, pp. 244–52, 450–54.

Sterling, Charles. "Observations on Petrus Christus." *The Art Bulletin,* 53 (March 1971): pp. 1–26, fig. 1.

Upton, Joel. "Petrus Christus." Ph.D. dissertation, Bryn Mawr College, 1972, no. 26, pp. 159–64, 392–96.

Schabacker, Peter H. *Petrus Christus.* Utrecht, 1974, pp. 132–34, as work erroneously attributed to Christus.

Panhans-Bühler, Ursula. *Eklektizismus und Originalität im Werk des Petrus Christus.* Vienna, 1978, no. 76, pp. 17, 34, 72–74, 123–25, 131–36, pl. 34.

Collier, James M. "The Kansas City Petrus Christus: Its Importance and its Dating." *The Nelson Gallery and Atkins Museum Bulletin,* 5, no. 5 (September 1979): pp. 27, 28, 34, fig. 4.

Wright, Joanne. "Antonello da Messina: The Origins of his Style and Technique." *Art History,* 3 (March 1980): pp. 44, 56.

Paolini, Maria Grazia. "Problemi antonelliani i rapporti con la pittura fiamminga." *Storia dell'arte,* no. 38/40 (1980): pp. 163–65.

Lurie, A. T. "Newly Discovered Eyckian St. John the Baptist in a Landscape." *Cleveland Museum Bulletin,* 67 (April 1981): pp. 105, 109, 118.

Exhibited:

New York. M. Knoedler and Co. *An Exhibition of Flemish Primitives.* April 13–May 9, 1942, pp. 22, 23, ill.

Cambridge, Massachusetts. Fogg Art Museum. *Early Flemish Painting.* February 17–March 20, 1948.

Washington, D.C. National Gallery of Art. 1952–1965.

9 Pieter Claesz

Acquired by the Putnam Foundation, 1970.

10 Claude Lorrain

Provenance: During the last two centuries the picture changed hands fairly frequently, but precise details of the changes of ownership have not yet come to light in all cases. The available evidence is as follows: probably de Merval (sold, Paris, May 9, 1768, lot 100); Sir Joshua Reynolds, by 1775 (sold, Christie's, London, March 17, 1795, lot 84; according to Caracciolo and Earlom, see below); Noel Desenfans (sold, March 18, 1802; according to Smith, see below); Lord Carrington, by 1842; The Reverend J. Staniforth, by 1857 (according to Waagen, see below); Hart Davis collection (according to Waagen, but unconfirmed); probably lot 85, W. A. L. Fletcher sale, Christie's, London, 1914; bought Cohen; Asscher, dealer, London, c. 1941; The Lady Dunsany, London, c. 1954 (sold, Christie's, London, November 25, 1966, lot 67); bought Owen. The sale catalogue adds John Bolton and Annabella, Lady Boughey to the list of previous owners, both unconfirmed. Acquired by the Putnam Foundation, 1969.

Literature:
Caracciolo, L., with engraved reproductions by R. Earlom. *Liber Veritatis di Claudio Gellée.* Rome, 1815.
Smith, John. *A Catalogue Raisonné of the Works of the Most Eminent Dutch, Flemish, and French Painters.* 9 vols. London, 1829–42, 8 (1837): pp. 245–46, perhaps also no. 346; and 9 (1842): *Supplement,* no. 12, p. 807.
Waagen, G. F. *Galleries and Cabinets of Art in Great Britain* (also known as *Art Treasures in Great Britain,* vol. 4). London, 1857, pp. 427–28.
Hind, A. *British Museum: Catalogue of the Drawings of Claude Lorrain.* London, 1926, no. 236.
Röthlisberger, M. "New Light on Claude Lorrain." *Connoisseur,* 145 (March 1960): p. 57, fig. 4.
————. *Claude Lorrain: The Paintings.* 2 vols. New Haven, Connecticut, 1961, 1: pp. 265–66; 2: fig. 184.
————. *Claude Lorrain: The Drawings.* 2 vols. Berkeley, 1968, 1: p. 239.
Cecchi, D. *L'opera completa di Claude Lorrain.* Introduction by Marcel Röthlisberger. Milan, 1975, no. 168.

Exhibited:
Washington, D.C. National Gallery of Art. *Claude Lorrain, 1600–1682.* Catalogue prepared by H. Diane Russell. October 17, 1982–January 2, 1983, no. 36, p. 159, ill.

11 François Clouet

Provenance: Chateau de Nantilly (the seat of the Bishops of Lyon); M. de Montgolfier; M. Lucien Brun, Chateau d'Essuly, near Lyon; private collection, Paris. Acquired by the Putnam Foundation, 1955.

Literature:
Mongan, Agnes and Elizabeth. *European Paintings in the Timken Art Gallery.* San Diego, 1969, no. 34, pp. 92, 93, 129–30, ill.

Exhibited:
Cambridge, Massachusetts. Fogg Art Museum. *Cranach and Clouet: Princely Portrait Drawings of the Northern Renaissance.* November 23–December 31, 1951.
New York. Metropolitan Museum of Art. 1956–1965.

12 Jean-Baptiste-Camille Corot

Acquired by the Putnam Foundation, 1955.

Literature:
Robaut, Alfred. *L'Œuvre de Corot.* 4 vols. Paris, 1905, 2: no. 367, pp. 130, 131, ill.
Mongan, Agnes and Elizabeth. *European Paintings in the Timken Art Gallery.* San Diego, 1969, no. 39, pp. 102, 103, 133, ill.

Exhibited:
Paris. Salon of 1838, no. 342, p. 44.
Washington, D.C. National Gallery of Art. 1956–1962.

13 Jacques-Louis David

Provenance: The painting remained in the Penrose family from the date of execution. Acquired by the Putnam Foundation, 1953.

Literature:
Blanc, Charles. *Histoire des Peintres français au XIXᵉ Siècle.* Paris, 1845, p. 211.
David, J.-L. Jules. *Le Peintre Louis David.* 2 vols. Paris, 1880, 1: p. 642.
Farington, Joseph. *The Farington Diary.* ed. James Grieg. 8 vols. London, 1922–28, 2 (1923): p. 45.
Cantinelli, Richard. *Jacques-Louis David.* Paris, 1930, no. 100, p. 110.
Holma, Klaus. *David: Son Evolution et son Style.* Paris, 1940, no. 106, p. 128.
Mongan, Agnes and Elizabeth. *European Paintings in the Timken Art Gallery.* San Diego, 1969, no. 38, pp. 100, 101, 132–33, ill.
Wildenstein, Daniel. *Documents complementaires au Catalogue de l'Œuvre de Louis David.* Paris, 1973, nos. 1386, 1810, 1938, pp. 161, 209, 226.
Schnapper, Antoine. *David: Témoin de son Temps.* Fribourg, 1980, pp. 208, 210, 211, fig. 121.

Exhibited:
New York. Metropolitan Museum of Art. 1953–1955.

Cambridge, Massachusetts. Fogg Art Museum. 1955–1965.

14 Jean-Honoré Fragonard

Provenance: Hippolyte Walferdin, Paris; Beurnonville, Paris; Camille Groult, Paris. Acquired by the Putnam Foundation, 1955.
Literature:
Vente Hippolyte Walferdin. Hôtel Drouot, Paris, April 3, 1880, no. 12, pp. 6–7 (bought by Beurnonville).
Portalis, Roger. *Honoré Fragonard: Sa Vie et son Œuvre.* Paris, 1889, p. 273.
Nolhac, Pierre de. *J. H. Fragonard.* Paris, 1906, p. 150.
Goncourt, Edmond and Jules de. *L'Art du dix-huitième Siècle.* 3 vols. Paris, 1914, 3: p. 335.
Grappe, Georges. *Fragonard: La Vie et l'Œuvre.* Monaco, 1946, p. 75.
Wildenstein, Georges. *The Paintings of Fragonard.* London, 1960, no. 446, pp. 297–98, fig. 188.
Mongan, Agnes and Elizabeth. *European Paintings in the Timken Art Gallery.* San Diego, 1969, no. 37, pp. 98, 99, 132, ill.
Mandel, Gabriel. *L'opera completa di Fragonard.* Introduction by Daniel Wildenstein. Milan, 1972, no. 379, pp. 102, 103, ill.
Exhibited:
Paris. Louvre. *Exposition de Tableaux, Statues et Objets d'Art au Profit de l'Œuvre des Orphelins d'Alsace-Lorrain.* 1885, no. 199, p. 60.
Minneapolis. Minneapolis Institute of Arts. *French XVIIIth Century Painters.* 1954, no. 11.
New York. Wildenstein & Co. *French XVIIIth Century Painters.* 1954, no. 11.
Chicago. The Art Institute of Chicago. 1956–1965.

15 French School

Acquired by the Putnam Foundation, 1964.

16 Frans Hals

Provenance: W. Unger, an artist who made an etching after the portrait, Amsterdam, 1872; Van der Willigen, Haarlem; Marczell de Nemes, Budapest and Paris, 1913; Baron M. L. Herzog, Budapest. Acquired by the Putnam Foundation, 1955.
Literature:
Bode, Wilhelm von. *Studien zur Geschichte der holländischen Malerei.* Braunschweig, 1883, p. 88.
Pflugk, Hartung J. von. "Hamburg, Die Weber'sche Gemäldesammlung." *Repertorium für Kunstwissenschaft,* 8 (1885): p. 82.
Woermann, Karl and Woltmann, Alfred. *Geschichte der Malerei.* 3 vols. in 4 pts. Leipzig, 1879–88, 3, pt. 2 (1888): p. 599.
Davies, Gerald S. *Frans Hals.* London, 1902, no. 187, p. 141.
Moes, E. W. *Frans Hals: Sa Vie et son Œuvre.* Brussels, 1909, no. 132, p. 106.
Hofstede de Groot, C. *A Catalogue Raisonné of the Works of the Most Eminent Dutch Painters of the Seventeenth Century.* 8 vols. London, 1908–27, 3 (1910): no. 280, p. 81.
Sale Galerie Weber, Hamburg. Rudolph Lepke's Kunst-Auctions-Haus, Berlin, February 20–22, 1912, no. 223, ill.
Miomandre, Francis de. "Les Idées d'un Amateur d'Art (Collection Marcel de Nemes)." *L'Art et les Artistes,* no. 96 (March 1913): p. 254, ill.
Mourey, Gabriel. "La Collection Marczell de Nemes." *Les Arts,* no. 138 (June 1913): p. 21, ill.
Vente Marczell de Nemes. Galerie Manzi, Joyant, Paris, June 17–18, 1913, no. 53, ill.
Bode, Wilhelm von, ed. *Frans Hals: His Life and Works.* 2 vols. London, 1914, 1: no. 145, p. 44, pl. 85a.
Valentiner, Wilhelm R. *Frans Hals.* Klassiker der Kunst. Stuttgart, 1923, no. 124, p. 314, pl. 124.
————. *Frans Hals Paintings in America.* Westport, 1936, no. 46, ill.
Trivas, N. S. *The Paintings of Frans Hals.* New York, 1941, no. 46, p. 41, pl. 68.
Gratama, G. D. *Frans Hals.* The Hague, 1943, no. 48, pp. 39, 48, pl. 48.
Mongan, Agnes and Elizabeth. *European Paintings in the Timken Art Gallery.* San Diego, 1969, no. 22, pp. 64, 65, 121–22, ill.
Slive, Seymour. *Frans Hals.* 3 vols. London, 1970, 3: no. 100, pp. 56–57; 2: pl. 158.
Grimm, Claus. *Frans Hals: Entwicklung, Werkanalyse, Gesamtkatalog.* Berlin, 1972, no. 65, pp. 91, 202.
Montagni, E. *L'opera completa di Frans Hals.* Introduction by Claus Grimm. Milan, 1974, no. 87, pp. 97–98, fig. 87.
Exhibited:
Düsseldorf. Kunsthistorische Ausstellung. *Katalogue.* Catalogue prepared by Firmenich-Richartz. 1904, no. 313, p. 133.
Düsseldorf. Städt. Kunsthalle Düsseldorf. *Katalog der aus der Sammlung des Kgl. Rates Marczell von Nemes—Budapest Ausgestellten Gemälde.* July–December 1912, no. 41, ill.
Los Angeles. Los Angeles Museum of History, Science, and Art. *Five Centuries of European Painting.* November 25–December 31, 1933, no. 14, ill.

San Francisco. California Palace of the Legion of Honor. *Exhibition Catalogue.* 1934, no. 23.

Detroit. The Detroit Institute of Arts. *An Exhibition of Fifty Paintings by Frans Hals.* January 10–February 28, 1935, no. 23, pl. 23.

Hartford. Wadsworth Atheneum. *Forty-three Portraits.* January 26–February 10, 1937, no. 17, ill.

Haarlem. Frans Hals Museum. *Frans Hals Tentoonstelling.* July 1–September 30, 1937, no. 50, p. 40, pl. 51.

New York. Schaeffer Galleries. *Paintings by Frans Hals.* 1937, no. 9, ill.

Providence. Rhode Island School of Design. *Dutch Paintings in the Seventeenth Century.* Catalogue prepared by Wolfgang Stechow. 1938, no. 18, pl. 18.

New York. Koetser Galleries. *Dutch Painting.* February 25–March 25, 1946, no. 12.

Los Angeles. Los Angeles County Museum. *Loan Exhibition of Paintings by Frans Hals, Rembrandt.* November 18–December 31, 1947, no. 5, p. 17, ill.

Cambridge, Massachusetts. Fogg Art Museum. 1960–1965.

17, 18 Nicolas de Largillierre

Provenance: by a series of indirect inheritances to Comte Olivier de La Ferriere (sold, 1969). Acquired by the Putnam Foundation, 1971.
Literature:
Perez, Marie-Félicie. "Collectionneurs et Amateurs d'Art à Lyon au XVIIIᵉ Siècle." *Revue de l'Art,* no. 47 (1980): pp. 44, 45, 51, n. 19, figs. 1, 2.

19 Luca di Tommè

Provenance: In Paris in 1930s; T. S. Hyland, Greenwich, Connecticut. Acquired by the Putnam Foundation, 1967.
Literature:
Meiss, Millard. *Painting in Florence and Siena after the Black Death.* Princeton, 1951, pp. 34–35, fig. 50.
Braunfels, Wolfgang. *Die heilige Dreifaltigkeit.* Düsseldorf, 1954, p. XLI, fig. 42 (cf. pp. XXXV–XL, figs. 38, 39).
Meiss, Millard. "Notes on Three Linked Sienese Styles." *Art Bulletin,* 45 (March 1963): pp. 47–48.
Berenson, Bernard. *Italian Pictures of the Renaissance, a List of the Principal Artists and their Works with an Index of Places: Central Italian and North Italian Schools.* 3 vols. London, 1968, 1: p. 226.
Os, H. W. van. *Marias Demut und Verherrlichung in der sienesischen Malerei 1300–1450.* 's-Gravenhagen, 1969, pp. 68, n. 94, n. 96, 71, n. 109.
Mongan, Agnes and Elizabeth. *European Paintings in the Timken Art Gallery.* San Diego, 1969, no. 3, pp. 22, 23, 107–8, ill.
Fehm, Sherwood A., Jr. "Luca di Tommè." 4 vols. Ph.D. dissertation, Yale University, 1971, 1: no. 4, pp. 6, 26, n. 5, 30, n. 11, 31, 37–42, 46, 83, 107–8, catalogue raisonné p. 5.
Fredericksen, Burton and Zeri, Federico. *Census of Pre-Nineteenth Century Italian Paintings in North American Public Collections.* Cambridge, Massachusetts, 1972, pp. 113, 268, 272, 284, 291, 295, 297, 302, 360, 632.
Fehm, Sherwood A., Jr. *The Collaboration of Niccolò Tegliacci and Luca di Tommè.* J. Paul Getty Museum

Publication, no. 5. Malibu, California, 1973, p. 30.
Benedictis, C. de. *La pittura senese 1330–1370.* Florence, 1979, pp. 48, 67, n. 79, 88, fig. 90.
Fehm, Sherwood A. *Luca di Tommè: A Sienese Fourteenth Century Painter.* Carbondale, Illinois, forthcoming.
Exhibited:
Baltimore. The Walters Art Gallery. *The International Style.* Catalogue prepared by Philippe Verdier and Dorothy Miner. October 23–December 2, 1962, no. 17, pl. IX.
Hartford. Wadsworth Atheneum. *An Exhibition of Italian Panels & Manuscripts from the Thirteenth & Fourteenth Centuries in Honor of Richard Offner.* April 9–June 6, 1965, no. 32, p. 28.

20 The Magdalen Master and the Master of San Gaggio

Provenance: S. Maria dei Candeli, Florence (possible owner); Art Market, Florence; Jacob Hirsch; T. S. Hyland, Greenwich, Connecticut. Acquired by the Putnam Foundation, 1967.
Literature:
Offner, Richard. *An Early Florentine Dossal.* Florence, n.d.
Garrison, Edward B. "The Oxford Christ Church Library Panel and the Milan Sessa Collection Shutters: A Tentative Reconstruction of a Tabernacle and a Group of Romanizing Florentine Panels." *Gazette des Beaux-Arts,* 29 (June 1946): pp. 321–46, fig. 27, central panel by Magdalen Master, scenes by Fourth Romanizing Florentine Master.
————. *Italian Romanesque Panel Paintings.* Florence, 1949, no. 367, p. 142.

Meiss, Millard. *Painting in Florence and Siena after the Black Death*. Princeton, 1951, p. 129, fig. 118 (reproduces Christ Disrobing).

Previtali, Giovanni. *Giotto e la sua bottega*. Milan, 1967, pp. 27, 30, 133, n. 44, fig. 27 (reproduces Entombment), scenes by Master of S. Gaggio.

Mongan, Agnes and Elizabeth. *European Paintings in the Timken Art Gallery*. San Diego, 1969, no. 1, pp. 18, 19, 107, ill.

Fredericksen, Burton and Zeri, Federico. *Census of Pre-Nineteenth Century Italian Paintings in North American Public Collections*. Cambridge, Massachusetts, 1972, pp. 53, 131, 281, 283, 284, 285, 286, 288, 294, 297, 298, 310, 632, central panel by Magdalen Master, scenes by follower of Cimabue.

Boskovits, Miklos. *Cimabue e i precursori di Giotto*. Florence, 1976, no. 70, n. 4, scenes by Master of S. Gaggio.

Exhibited:

Hartford. Wadsworth Atheneum. *An Exhibition of Italian Panels & Manuscripts from the Thirteenth & Fourteenth Centuries in Honor of Richard Offner*. April 9–June 6, 1965, no. 2, p. 11, ill.

21 Master of the Saint Lucy Legend, attributed to

Provenance: M. Chillingworth, Nuremberg; Albert J. Kobler, New York; Mrs. Edward A. Westfall, New York. Acquired by the Putnam Foundation, 1955.

Literature:

Catalogue de la Collection Chillingworth: Tableaux anciens XIII à XVII Siècles. Galeries Fischer, Lucerne, September 5, 1922, no. 9, p. 9, ill.

Friedländer, Max J. *Die Altniederländische Malerei*. 14 vols. Berlin and Leiden, 1924–37, 6 (1928): no. 144, p. 140.

Mongan, Agnes and Elizabeth. *European Paintings in the Timken Art Gallery*. San Diego, 1969, no. 16, pp. 50, 51, 115–16, ill.

Exhibited:

New York. F. Kleinberger Galleries, Inc. *Catalogue of a Loan Exhibition of Flemish Primitives*. Catalogue prepared by Harry G. Sperling. October 28–November 16, 1929, no. 40, pp. 126, 127, ill.

New York. Duveen Art Galleries. *Catalogue of Exhibition of Flemish Paintings*. 1946, no. 2, ill.

New York. Metropolitan Museum of Art. 1956–1965.

22 Gabriel Metsu

Provenance: The Dowager Boreel, Amsterdam; Mr. Stanley, London, 1815; Madame Le Rouge, Paris; Duke of Arenberg, Brussels. Acquired by the Putnam Foundation, 1958.

Literature:

Vente Boreel. Amsterdam, September 23, 1814, no. 8, pp. 6–7.

Vente Le Rouge. Paris, April 27, 1818, no. 34, p. 22.

Spruyt, Charles. *Lithographies d'après les principaux Tableaux de la Collection de A. S. Monseigneur le Prince Auguste d'Arenberg avec le Catalogue descriptif*. Brussels, 1829, no. 54, p. 10.

Smith, John. *A Catalogue Raisonné of the Works of the Most Eminent, Dutch, Flemish, and French Painters*. 9 vols. London, 1829–42, 4 (1838): no. 70, pp. 95, 96.

Buerger, W. [Théophile Etienne Joseph Thoré]. *Galerie d'Arenberg à Bruxelles*. Brussels, 1859, no. 36, pp. 140–41.

Marguillier, Auguste. "L'Exposition des Maîtres anciens à Düsseldorf." *Gazette des Beaux-Arts,* 32 (1904): p. 284.

Hofstede de Groot, C. *A Catalogue Raisonné of the Works of the Most Eminent Dutch Painters of the Seventeenth Century*. 8 vols. London, 1908–27, 1 (1908): no. 183, pp. 310–11 (cf. nos. 24, 262).

Plietzsch, Eduard. "Gabriel Metsú." *Pantheon,* 17 (January 1936): p. 5, ill.

Mongan, Agnes and Elizabeth. *European Paintings in the Timken Art Gallery*. San Diego, 1969, no. 26, pp. 72, 73, 123–24, ill.

Robinson, Franklin W. *Gabriel Metsu*. New York, 1974, pp. 39–40, 41, 60, 81, fig. 76, frontispiece.

Exhibited:

Brussels. Ducal Palace. 1855.

Düsseldorf. Kunsthistorische Ausstellung. *Katalogue*. Catalogue prepared by Firmenich-Richartz. 1904, no. 341, p. 143.

Cambridge, Massachusetts. Fogg Art Museum. 1960–1965.

23 Gustave Moreau

Provenance: Brame; Marmontel (Marmontel sale, Paris, Hôtel Drouot, January 25–26, 1883, no. 211, where presumably bought in, as it was featured again in another Marmontel sale, Paris, Hôtel Drouot, March 28–29, 1898, no. 172); Ernest Cronier (sold, Paris, Galerie Petit, December 4–5, 1905, no. 74); Gustave Berly. Acquired by the Misses Anne and Amy Putnam.

Literature:

Leprieur, P. "Gustave Moreau et son Œuvre." *L'Artiste,* 1 (March 1889): p. 168, as *Le Massier*.

Deshairs, Léon and Laran, Jean. *Gustave Moreau*. Paris, 1913, p. 78.

Mathieu, P.-L. *Gustave Moreau*. Oxford, 1977, no. 179, p. 327.

Exhibited:

Paris. Galerie Petit. *Gustave Moreau*. 1906, no. 12, as *Le Porte-etendard* (then in the collection of Gustave Berly).

San Bernardino, California. The Art Gallery, California State College, San Bernardino. *Symbolism: Europe and America at the End of the Nineteenth Century*. April 27–June 10, 1980, no. 31.

24 Bartolomé Esteban Murillo

Provenance: Kaunitz collection, Vienna, c. 1820–60; Count Czernin, Vienna. Acquired by the Putnam Foundation, 1955.

Literature:

Alfonso, Luis. *Murillo*. Barcelona, 1886, no. 1, p. 219.

Justi, Carlo. *Murillo*. Leipzig, 1904, p. 72.

Calvert, Albert F. *Murillo*. London, 1907, pl. 56.

Mayer, August L. *Murillo*. Klassiker der Kunst. Stuttgart, 1913, p. 95, ill.

Wilczek, Karl. *Katalog der Graf Czernin'schen Gemäldegalerie in Wien*. Vienna, 1936, no. 48, p. 60.

Mongan, Agnes and Elizabeth. *European Paintings in the Timken Art Gallery*. San Diego, 1969, no. 32, pp. 86, 87, 128, ill.

Íñiguez, Diego Angulo. *Murillo*. 3 vols. Madrid, 1981, 2: no. 268, p. 226; 3: fig. 398.

Exhibited:

Sion, Switzerland. Musée de la Majorie. *La Collection Czernin de Vienne*. July 17–October 15, 1951, no. 27.

Washington. National Gallery of Art. 1957–1965.

25 Niccolò di Buonaccorso

Provenance: Frederick Mont, New York (as Paolo di Giovanni Fei); T. S. Hyland, Greenwich, Connecticut. Acquired by the Putnam Foundation, 1967.

Literature:

Berenson, Bernard. *Italian Pictures of the Renaissance, a List of the Principal Artists and their Works with an Index of Places: Central Italian and North Italian Schools*. 3 vols. London, 1968, 1: p. 294.

Mongan, Agnes and Elizabeth. *European Paintings in the Timken Art Gallery*. San Diego, 1969, no. 4, pp. 24, 25, 108, ill.

Fredericksen, Burton and Zeri, Federico. *Census of Pre-Nineteenth Century Italian Paintings in North American Public Collections*. Cambridge, Massachusetts, 1972, pp. 149, 291, 302, 314, 381, 388, 632.

Exhibited:

Baltimore. The Walters Art Gallery. *The International Style*. Catalogue prepared by Philippe Verdier and Dorothy Miner. October 23–December 2, 1962, no. 25, pl. XV.

Hartford. Wadsworth Atheneum. *An Exhibition of Italian Panels & Manuscripts from the Thirteenth & Fourteenth Centuries in Honor of Richard Offner*. April 9–June 6, 1965, no. 32, p. 28.

26 Rembrandt Harmenszoon van Rijn

Provenance: Prince Lavalle (who took it to Russia with him during the reign of Catherine II); Princess Troubetskoy (daughter of Prince Lavalle); Princess Davidoff (daughter of Princess Troubetskoy); Prince Wassili Davidoff, Kiev (grandson of Princess Davidoff); Henry Goldman, New York. Acquired by the Putnam Foundation, 1952.

Literature:

Bode, Wilhem von. "Neu entdeckte und wiedererstandene Gemälde von Rembrandt." *Der Cicerone*, 4 (July 1912): pp. 505–8, ill.

Hofstede de Groot, C. *A Catalogue Raisonné of the Works of the Most Eminent Dutch Painters of the Seventeenth Century*. 8 vols. London, 1908–27, 6 (1916): no. 169, p. 120.

Valentiner, Wilhelm R. *Rembrandt: Wiedergefundene Gemälde*. Klassiker der Kunst. Stuttgart, 1921, p. 82, ill.

———. *The Henry Goldman Collection*. New York, 1922, no. 14, ill.

Gronau, Georg. "Die Sammlung Henry Goldman." *Der Kunstwanderer*, 6 (1924): p. 345.

Freund, Frank E. Washburn. "Eine Ausstellung niederländischer Malerei in Detroit." *Der Cicerone*, 17 (May 1925): pp. 461, 463, ill.

Weisbach, Werner. *Rembrandt*. Berlin, 1926, pp. 577–78, 626.

Valentiner, W. R. "The Henry Goldman Collection." *Art News*, 25, no. 32 (May 14, 1927): p. 17, ill.

———. "Important Rembrandts in American Collections." *Art News*, 28, no. 30 (April 26, 1930): p. 65, ill.

Bredius, A. *The Paintings of Rembrandt*. London, 1937, no. 613, p. 26, ill.

Bauch, Kurt. *Rembrandt Gemälde*. Berlin, 1966, no. 217, p. 12, ill.

Lee, Sherman E. "Rembrandt: *Old Man Praying*." *The Bulletin of the Cleveland Museum of Art*, 54 (December 1967): p. 301, n. 7.

Gerson, Horst. *Rembrandt Paintings*. Amsterdam, 1968, no. 296, p. 378, ill.

Hamann, Richard. *Rembrandt.* Berlin, 1969, p. 460.

Lecaldano, Paolo. *L'opera pittorica completa di Rembrandt.* Introduction by Giovanni Arpino. Milan, 1969, no. 357, pp. 118, 119, ill.

Mongan, Agnes and Elizabeth. *European Paintings in the Timken Art Gallery.* San Diego, 1969, no. 23, pp. 66, 67, 122–23, ill.

Benesch, Otto. *Collected Writings.* ed. Eva Benesch. 4 vols. London, 1970–73, I (1970): *Rembrandt,* pp. 192–93, fig. 159.

Roger-Marx, Claude. *Rembrandt.* Paris, 1972, p. 342.

Bolten, J. and Bolten-Rempt, H. *The Hidden Rembrandt.* Oxford, 1978, no. 470, p. 198, ill.

Brown, Christopher. *Rembrandt: Every Painting.* 2 vols. New York, 1980, 2: no. 315, p. 58, ill.

Exhibited:

New York. Metropolitan Museum of Art. 1913–1914.

Detroit. The Detroit Institute of Arts. *Catalogue of a Loan Exhibition of Dutch Paintings of the Seventeenth Century.* January 9–25, 1925, no. 22.

Detroit. The Detroit Institute of Arts. *Catalogue of a Loan Exhibition of Paintings by Rembrandt.* May 2–31, 1930, no. 59, ill.

Toronto. Toronto Art Museum. *Rembrandt Exhibition.* 1951, no. 10.

Washington. National Gallery of Art. 1952–1965.

27 Peter Paul Rubens

Provenance: Mr. Alfred Seymour; Miss Seymour (sold, Christie's, London, January 23, 1920, lot 98, described as the Duke of Burgundy); Leonard Gow, Glasgow, 1921; Henry Goldman, New York. Acquired by the Putnam Foundation, 1952.

Literature:

Brockwell, Maurice W. "A Newly Discovered Rubens Portrait." *Burlington Magazine,* 39 (December 1921): pp. 284, 285, ill.

Conway, Sir Martin. *Catalogue of the Loan Exhibition of Flemish and Belgian Art: Memorial Volume.* Royal Academy of Arts, Burlington House, London, 1927, no. 258, p. 106.

Schneider, Hans. "Die Ausstellung flämischer und belgischer Kunst in London." *Zeitschrift für Bildende Kunst* (Leipzig), 61 (1927): no. 61, p. 43.

Glück, Gustav. *Rubens, Van Dyck und Ihr Kreis.* Vienna, 1933, pp. 8–9, 374 (h).

Goris, Jan-Albert and Held, Julius S. *Rubens in America.* New York, 1947, no. 9, p. 27, pl. 4.

Jaffé, Michael. "The Deceased Young Duke of Mantua's Brother." *Burlington Magazine,* 103 (September 1961): pp. 374–78, ill.

Mongan, Agnes and Elizabeth. *European Paintings in the Timken Art Gallery.* San Diego, 1969, no. 19, pp. 56, 57, 117–18, ill.

National Centrum voor de Plastische Kunsten voor de XVIde en XVIIde Eeuw, gen. ed. *Corpus Rubenianum Ludwig Burchard.* 26 vols. London, Brussels, and Antwerp, 1968–, 19 (1977): *Portraits I,* by Frances Huemer, pp. 127–28.

Exhibited:

London. Royal Academy of Arts. *Exhibition of Flemish and Belgian Art, 1300–1900.* 1927, no. 258, p. 98.

New York. New York World's Fair. *Masterpieces of Art, Catalogue of European Paintings and Sculpture from 1300–1800.* May–October 1939, no. 320, pp. 156–57, pl. 60.

London. Wildenstein and Co. Ltd. *A Loan Exhibition of Works by Peter Paul Rubens, Kt.* Catalogue prepared by Ludwig Burchard. October 4–November 11, 1950, no. 30, pp. 36–37, frontispiece.

New York. Wildenstein and Co. *A Loan Exhibition of Rubens.* February 20–March 31, 1951, no. 2, pp. 12, 33, ill.

New York. Metropolitan Museum of Art. 1953–1965.

28 Jacob Isaacksz van Ruisdael

Provenance: The Stroganoff Museum, St. Petersburg; Count S. A. de Stroganoff; Professor Kocher, Bern; Mademoiselle Maurer, La Tour-de-Peilz, Switzerland. Acquired by the Putnam Foundation, 1954.

Literature:

Rosenberg, Jakob. *Jacob van Ruisdael.* Berlin, 1928, no. 50, p. 75.

"Countrywide Loans from California." *Art News,* 55, no. 7 (November 1956): p. 33, ill.

Mongan, Agnes and Elizabeth. *European Paintings in the Timken Art Gallery.* San Diego, 1969, no. 25, pp. 70, 71, 123, ill.

Exhibited:

New York. Metropolitan Museum of Art. 1956–1965.

29 Giovanni Girolamo Savoldo

Provenance: Dr. William Dean, England (sold, Sotheby's, London, April 1960, no. 91). Acquired by the Putnam Foundation, 1965.

Literature:

Boschetto, Antonio. *Giovan Gerolamo Savoldo.* Milan, 1963, text opposite pls. 16/17, pls. 14–18.

Mongan, Agnes and Elizabeth. *European Paintings in the Timken Art*

Gallery. San Diego, 1969, no. 8, pp. 32, 33, 110–11, ill.

Fredericksen, Burton and Zeri, Federico. *Census of Pre-Nineteenth Century Italian Paintings in North American Public Collections.* Cambridge, Massachusetts, 1972, pp. 184, 373, 632.

Jacobsen, Michael A. "Savoldo and Northern Art." *Art Bulletin,* 56 (December 1974): pp. 530–34.

Exhibited:

Waltham, Massachusetts. The Rose Art Museum, Brandeis University. *Major Masters of the Renaissance.* Catalogue prepared by Creighton Gilbert. May 3–June 9, 1963, no. 16, pp. 23–24, ill.

30 Bartolomeo Veneto

Provenance: Manfrin collection, Venice; Mr. Barker (according to Crowe and Cavalcaselle, see below); 5th Earl of Rosebery, Mentmore Towers, by 1884 (sold, Sotheby's, Mentmore Towers, May 25–26, 1977, lot 2407). Acquired by the Putnam Foundation, 1979.

Literature:

London. National Gallery. MS. "Inventory and Valuation of Pictures made from the Manfrin Collection at Venice." 1851, no. 52.

Zanotto, F. *Nuovissima guida di Venezia.* Venice, 1856. p. 342.

Mentmore. 2 vols. Edinburgh, 1884, I: no. 14, p. 68.

Crowe, J. A. and Cavalcaselle, G. B. *A History of Painting in North Italy.* 3 vols. London, 1912, I: p. 299.

Berenson, Bernard. *Italian Pictures of the Renaissance: Venetian School.* 2 vols. London, 1957, I: p. 12.

Gilbert, Creighton. "Bartolommeo Veneto and his Portrait of a Lady." *National Gallery of Canada Bulletin,*

22 (1973): pp. 3, 7, 12, n. 5, 15, n. 16, fig. 3.

31 Claude Joseph Vernet

Provenance: Probably the Comte de Merle (sold, Ph. F. Julliot fils, Paris, March 1–4, 1784); bought Paillet, a dealer (according to a manuscript note against this lot in the copy of the aforementioned sale catalogue in the library of the National Gallery, London); Luttrellstown Castle, Clonsilla, Ireland. It has been suggested that the painting was bought about 1800 by Luke White, a member of the Irish Parliament, when he bought the house for the Luttrell family, from whom it passed to the Guinnesses, the last of whom to own it was the Honorable Mrs. [Aileen] Plunket [née] Guinness (sold, Sotheby's, London, July 13, 1977, lot 8). Acquired by the Putnam Foundation, 1978.

Literature:

Joullain, C. F. *Répertoire des Tableaux, Dessins et Estampes, Ouvrage utile aux Amateurs.* Paris, 1793, p. 97.

Lagrange, Léon. *Les Vernet: Joseph Vernet et la Peinture au XVIIIᵉ Siècle.* Paris, 1864, pp. 29, 472.

Ingersoll-Smouse, Florence. *Joseph Vernet: Peintre de la Marine, 1714–1789.* 2 vols. Paris, 1926, I: no. 246, p. 55.

Guinness, D. and Ryan, W. *Irish Houses and Castles.* New York, 1971, p. 142.

Exhibited:

Dublin. Municipal Gallery of Modern Art. *Paintings from Irish Collections.* 1957, no. 69.

London. Kenwood. *Claude Joseph Vernet.* 1976, no. 17, ill.

Paris. Musée de la Marine, Palais de Chaillot. *Joseph Vernet, 1714–1789.* October 15, 1976–January 9, 1977, no. 19, p. 57, ill.

32 Paolo Caliari, called Veronese

Provenance: Possibly mentioned by Ridolfi (see below), in the possession of the heirs of Veronese; according to Cicogna (see below) the work belonged to Abbott Celotti; Boudon, Paris, until 1831; Quantock; Norman Clark Neill, Cowes, as of 1925; Mrs. H. F. Buxton, London. Acquired by the Putnam Foundation, 1956.

Literature:

Ridolfi, C. *Le maraviglie dell'arte ovvero le vite degl'illustri pittori veneti e dello stato . . .* (1648). 2 vols. ed. D. von Hadeln. Berlin, 1914–24, I (1914): p. 344.

Catalogue of the Boudon Sale. Paris, June 8, 1831, no. 10.

Cicogna, E. *Delle iscrizioni veneziane.* 6 vols. Venice, 1824–53, 4 (1834): p. 235.

Osmond, Percy H. *Paolo Veronese.* London, 1927, p. 32.

"Countrywide Loans from California." *Art News,* 55, no. 7 (November 1956): p. 33, ill.

Berenson, Bernard. *Italian Pictures of the Renaissance: Venetian School.* 2 vols. London, 1957, I: p. 135.

Marini, Remigio. *L'opera completa del Veronese.* Introduction by Guido Piovene. Milan, 1968, no. 392, p. 135.

Mongan, Agnes and Elizabeth. *European Paintings in the Timken Art Gallery.* San Diego, 1969, no. 10, pp. 36, 37, 111, ill.

Fredericksen, Burton and Zeri, Federico. *Census of Pre-Nineteenth Century Italian Paintings in North American Public Collections.* Cambridge, Massachusetts, 1972, pp. 40, 348, 632.

Pignatti, Terisio. *Veronese.* 2 vols. Venice, 1976, I: no. 129, pp. 125–26; 2: fig. 373.

Ticozzi, P. "Le incisioni da Paolo Veronese nel museo Correr." *Bolletino dei musei civici veneziani,* 20, no. 3–4 (1975): no. 130, p. 46.
Exhibited:
London. Burlington Fine Arts Club. *Winter Exhibition Catalogue.* 1925–1926, no. 61.
Washington, D.C. National Gallery of Art. 1956–1965.

33 Emanuel de Witte

Provenance: Jean-Louis Turrentine, Geneva, c. 1760; by descent to Madame Louis Perrot de Montmollin (sold, Christie's, London, June 27, 1969, lot 71). Acquired by the Putnam Foundation, 1970.

34 Albert Bierstadt

Provenance: American Insurance Company, Boston; gift to John Ingersoll Bowditch, 1864; to his son, Charles Pinckney Bowditch, 1889; to his son, Harold Bowditch, Brookline, Massachusetts, 1919. Acquired by the Putnam Foundation, 1966.
Literature:
New York Evening Post, June 9, 1864, p. 1, col. 3.
Ludlow, Fitz Hugh. *The Heart of the Continent.* New York, 1870, ill. opposite p. 438.
Trump, Richard Shafer. "Life and Works of Albert Bierstadt," Ph.D. dissertation, Ohio State University, 1963, p. 218.
Hendricks, Gordon. *Albert Bierstadt: Painter of the American West.* New York, 1973, no. 17, pp. 132, 155, 326, fig. 1 (frontispiece).

35 Thomas Birch

Acquired by the Putnam Foundation, 1973.

36 Martin Johnson Heade

Provenance: U.S. Senator George Hearst of California, Washington, D.C.; given on May 2, 1890, to Peter Petersen Toft of London; William Postar, Boston. Acquired by the Putnam Foundation, 1965.
Literature:
Stebbins, Theodore E., Jr. *The Life and Works of Martin Johnson Heade.* New Haven, Connecticut, 1975, no. 327, pp. 174, 276, ill.
Novak, Barbara. *Nature and Culture: American Landscapes and Painting, 1825–1875.* New York, 1980, pp. 122, 127, fig. 65.
Exhibited:
Tulsa, Oklahoma. Philbrook Art Center (and Oakland Museum, Baltimore Museum of Art, and New York, National Academy of Design). *Painters of the Humble Truth: Masterpieces of American Still Life, 1801–1939.* Catalogue prepared by William Gerdts. September 27–November 8, 1981, pp. 13, 130, pl. 13.

37 Winslow Homer

Provenance: Estate of Susan B. Maynard, Boston; to Samuel Haydock, Dedham, Massachusetts, John P. Maynard, Dover, Massachusetts, and Mrs. Hope M. Reichl, Burlington, Vermont. Acquired by the Putnam Foundation, 1964.
Literature:
Downes, William Howe. *The Life and Works of Winslow Homer.* Boston, 1911, p. 81.
Adams, Karen M. "Black Images in Nineteenth-Century American Literature: An Iconological Study of Mount, Melville, Homer, and Mark Twain," Ph.D. dissertation,

Emory University, 1977, p. 128, fig. 49.
Quick, Michael. "Homer in Virginia." *Los Angeles County Museum of Art Bulletin,* 24 (1978): p. 24.
Hendricks, Gordon. *The Life and Work of Winslow Homer.* New York, 1979, pp. 104, 279.
Calo, Mary Ann. "Winslow Homer's Visits to Virginia During Reconstruction." *The American Art Journal,* 12 (Winter 1980): p. 14.
Exhibited:
New York. National Academy of Design. *Ninth Annual Exhibition of the American Water Color Society.* 1876.
Philadelphia. *Centennial Exhibition.* 1876, no. 388, p. 28.
New York. Whitney Museum of American Art (and Los Angeles County Museum of Art and The Art Institute of Chicago). *Winslow Homer.* April 3–June 3, 1973, no. 81, p. 70, ill.
Los Angeles. Los Angeles County Museum of Art. November 6–December 12, 1977.

38 George Inness

Provenance: Williams and Everett Art Gallery, Boston, Massachusetts; Arthur Hunnewell; his daughter, Jane B. Hunnewell, Wellesley, Massachusetts. Acquired by the Putnam Foundation, 1972.

39 Eastman Johnson

Provenance: Auguste Richard, 1880 to at least 1893. Acquired by the Putnam Foundation, 1972.
Literature:
Benjamin S. G. W. "A Representative American." *The Magazine of Art,* 5 (1882): p. 489, ill. (reprinted in

Meynell, Wilfrid, ed. *Some Modern Artists and Their Work.* London, 1883, pp. 153–59, ill. and Meynell, Wilfrid, ed. *The Modern School of Art.* 3 vols. London, n.d. [probably 1886–88], 1: pp. 225–32, ill.).

Cook, Clarence. *Art and Artists of Our Time.* 3 vols. New York, 1888, 3: pp. 245, 263, ill.

Hartmann, Sadakichi. "Eastman Johnson: American Genre Painter." *International Studio,* 34, no. 134 (April 1908): p. 109, ill.

Hills, Patricia. *The Genre Painting of Eastman Johnson: Sources and Development of his Style and Themes* (Ph.D. dissertation, New York University, 1973). New York, 1977, pp. 151–54, 724, ill.

Williams, Hermann Warner, Jr. *Mirror to the American Past.* Greenwich, Connecticut, 1973, pp. 149–50, fig. 139.

Lancaster, Clay. *Nantucket in the Nineteenth Century.* New York, 1979, p. 15.

Exhibited:

New York. National Academy of Design. *55th Annual Exhibition of the National Academy of Design.* 1880, no. 382.

New York. Metropolitan Museum of Art. *Loan Collection of Paintings and Sculpture in the West Galleries and the Grand Hall.* November 1881–April 1882, no. 10.

New York. Metropolitan Museum of Art. *Loan Collection of Paintings and Sculpture in the West Galleries and the Grand Hall.* May–October 1882, no. 174.

Chicago. *World's Columbian Exposition.* 1893, no. 621.

Atlanta. The High Museum of Art. *The Beckoning Land.* April 17–June 13, 1971, no. 44.

New York. Whitney Museum of American Art. *Eastman Johnson.* Catalogue prepared by Patricia Hills. March 28–May 14, 1972, no. 97, pp. 92, 97, 101, ill.

Washington, D.C. National Gallery of Art. *American Light: The Luminist Movement.* February 10–June 15, 1980, pp. 48, 49, 146, fig. 46.

Evanston, Illinois. Terra Museum of American Art. *Life in 19th Century America.* September 11–November 15, 1981, no. 2, p. 35, frontispiece.

40 Frederic Remington

Provenance: Commissioned by Benjamin Walworth Arnold of Albany, New York; descended to his grandson, Arnold Cogswell of Albany. Acquired by the Putnam Foundation, 1977.

Literature:

McCracken, Harold. *The Frederic Remington Book.* Garden City, New Jersey, 1966, p. 110, fig. 143.

Exhibited:

Palm Springs. Palm Springs Desert Museum. *The West as Art.* February 24–May 30, 1982, no. 121, pl. 100.

41 Theodore Robinson

Provenance: Mr. Coburn, Waltham, Massachusetts; Nina Fitzgerald Holl, Waltham, Massachusetts; by bequest to First Church of Christ, Scientist, Boston. Acquired by the Putnam Foundation, 1975.

Exhibited:

Paris. Salon of 1888, no. 2164.

Paris. Universal Exposition. 1889, no. 260.

Worcester, Massachusetts. Worcester Art Museum. *Theodore Robinson, 1852–1892* (exhibition organized by the Baltimore Museum of Art; not included in the catalogue or exhib-ited in Baltimore). September 19–October 28, 1973.

42 Benjamin West

Acquired by the Putnam Foundation, 1969.

Literature:

Smith, John Chaloner. *British Mezzotinto Portraits.* London, [1878–] 1884, pp. 250, 598.

Cambridge, Massachusetts. Fogg Art Museum. *Grenville L. Winthrop: Retrospective for a Collector.* January 23–March 31, 1969, p. 132.

Dillenberger, John. *Benjamin West: The Context of his Life's Work with Particular Attention to Paintings with Religious Subject Matter.* San Antonio, Texas, 1977, pp. 25, 192, 211.

Bradley, Laurel. "Eighteenth-Century Paintings and Illustrations of Spenser's *Faerie Queen:* A Study in Taste." *Marsyas,* 20 (1979–80): p. 51.

Gerdts, William. "*Hermia and Helena* by Washington Allston." *Christie's Review of the Season 1982.* ed. Tim Ayers. London, 1982, pp. 39, 40, fig. 4.

Exhibited:

London. Royal Academy of Arts. 1777, no. 364.

Index